WATERSCAPE
PAINTING

WATERSCAPE PAINTING

John Cooke

B.T. Batsford Ltd London

ISBN 0 7134 5321 4

Typeset by Servis Filmsetting Ltd, Manchester

Printed in Great Britain by
R.J. Acford Ltd.
Chichester, Sussex
for the publishers B.T. Batsford Ltd
4 Fitzhardinge Street, London W1H 0AH

Contents

Acknowledgements

I should like to express my gratitude to all those collectors of my work who sent photographs for use in this book, sometimes at no small inconvenience to themselves. I am sorry that it has not been possible to use them all, owing to the very generous response to my requests.

My thanks are also due to Shell U.K. Ltd, Royle Publications Ltd, London Transport and *Leisure Painter*, for permission to use work commissioned and published by them.

Introduction

Of all the natural phenomena which delight the senses, those which seem to give the artist most pleasure and reward are the ones which are inconstant and variable: the wind, which can be violent and exciting or gentle and caressing, and visible only in the movement it gives to trees, meadows and pools; clouds, in their everchanging skyscape, towering as mountains or streaking the upper air with a breathtaking sense of space; snow, reflecting sunlight or turning the landscape into a stark contrast of dark sky and light ground; and – water.

Water is perhaps the most absorbing of all these phenomena. We can sit, sometimes for hours, by the river or the shore, watching and listening to the variety of delights which its flowing beauty offers us. I suspect that we owe our fascination for water to the fact that our deepest origins are there. We are largely made up of it, and all life originated in it and depends upon it. We turn to it for rest and relaxation, by the sea or on lake or river, fishing, sailing, swimming, paddling or just looking – and we are rarely disappointed.

When I was about 12, my parents gave me a book called *How to Draw Sail and Sea*. One little drawing in it took my fancy and, as far as I remember, it looked something like my drawing in Figure 1. In its simplicity, it depicted two of the most important facets of the visual impact water has on us, namely its surface features and reflections. The horizontal pencil smudges suggest the calm surface of water unruffled by any movement, and the boat is reflected in a slightly distorted way on this surface. A slightly darker sky enhances the suggestion of light on the water.

The back pages of my school exercise books became littered with sketches of boats of all shapes and sizes riding serenely at anchor on a calm sea; my imagination provided headlands and islands, also beautifully reflected in this wonderful mirror, for these boats to sail around.

Water does not, however, remain calm for long. Other aspects of nature exert their influence. The wind ruffles the surface and creates ripples, eventually building up large expanses of water into waves which break the surface mirror. Each little facet still reflects and throws light back towards us, until any recognizable reflected form is lost. Rainfall or thaw will swell rivers, and calm pools become raging torrents. Gravity draws the silken plane over the edge of rock fall and weir into plunging lines and furious disorder – a development from placid to exhilarating and, finally, awesome.

The time of day, the weather and the seasons all affect this marvellous, fluid element, and if, like me, you love a sense of light in paintings, water will give you ample opportunity to indulge in exciting effects which can impart mood and vitality to your work.

So far I have mentioned two aspects of the appearance of water – surface and reflections. Add to this objects seen through its translucence – the river bed or the submerged part of a post; things floating on its surface, such as leaves, twigs or boats; or shadows cast across its surface by the sun – and you will recognize that here we have a very complex subject to deal with when we treat water as a focal point of landscape painting.

This complexity can be quite daunting, but I am sure it explains why water stimulates the painter's eye. I hope what I have to say on the subject will show you how rewarding tackling these problems can be, and what pleasure you can gain and give once you understand the main points and develop the ability and skill to express them.

Water has always had a particular fascination for landscape painters, who have found it, along with all the other myriad details of the natural and man-made world, a means of introducing an exciting and stimulating feature into their work. However, it was not until the forerunners of Impressionism that the true feeling for water and its marvellously reflective powers was depicted with any real conviction. Leonardo da Vinci made extremely detailed studies of its characteristics, of the way it folded and poured between rocks and over ledges and the eddies and secondary currents which flowed through pools and broke into waves over a tumbled rocky bed. But this understanding of the mechanics of moving water was then applied to a style of painting which relied upon shape and form, and composition and design based on the traditions and skills inherited by artists from the flat, two-dimensional works of the Middle Ages and early Renaissance.

When men like Corot, Constable and Turner and the watercolourists such as Cotman and de Wint began to see the world about them in terms of light, and the world of the Impressionists began to unfold, then water in landscape paintings came into its own.

Painting is notorious for its classification into 'Isms', but in fact all of these groups overlapped – for example Pre-Raphaelites, famous for their precision and clarity, sometimes produced work with strong Impressionist tendencies. (Look at the background and water in

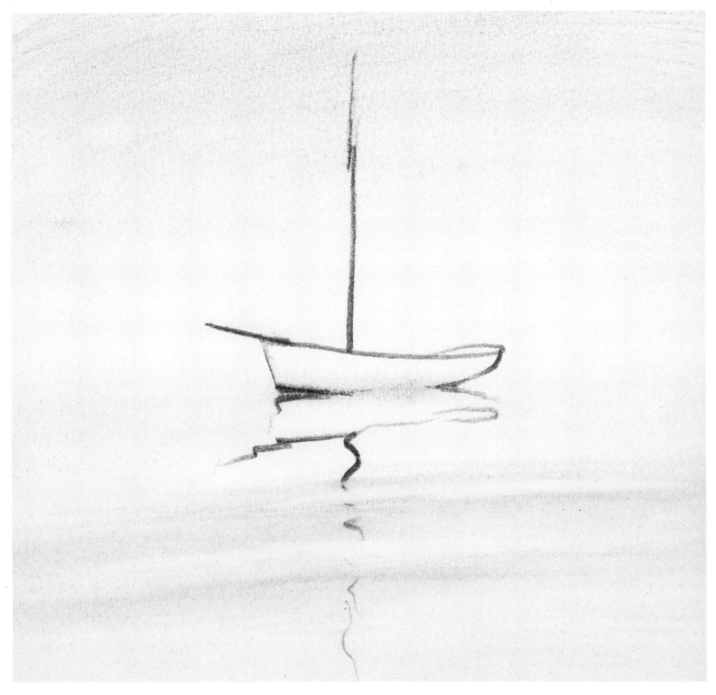

1 Simple boat sketch

William Waterhouse's *Lady of Shalott*.) And the Impressionists themselves eventually became expressionistic: Monet produced what must be the earliest Abstract Impressionist paintings in his later Giverny works of gardens and water-lilies.

We learn from the experience of those before us. When we admire paintings, we emulate, either consciously or subconsciously, the qualities about them which have made a particular impact on our sensibility. Corot is a painter for whom I have immense admiration, not only for the painterly characteristics of his work, the assured brush strokes and superb colour sense, but for the original way in which he saw and described water and used it to create paintings of immaculate composition and design. Earlier, Canaletto had depicted water in the

very formalized way of his time. Later, Alfred Sisley projected the same feeling as Corot for water, but using the broader, freer techniques of his fellow Impressionists.

The advent of the camera had a tremendous impact on the visual arts, freezing movement and capturing the transient effects of light which many artists were quick to seize on in order to impart that extra feeling of the moment captured on their canvases. Some used the photographic image simply to study for further reference for their work. Others actually painted from portions of or whole photographs, seeing in them an excellent opportunity to draw on a conveniently frozen moment in time. The implications as far as capturing and studying a moving element such as water are far-reaching and not as obvious as they may at first seem. The stigma of copying

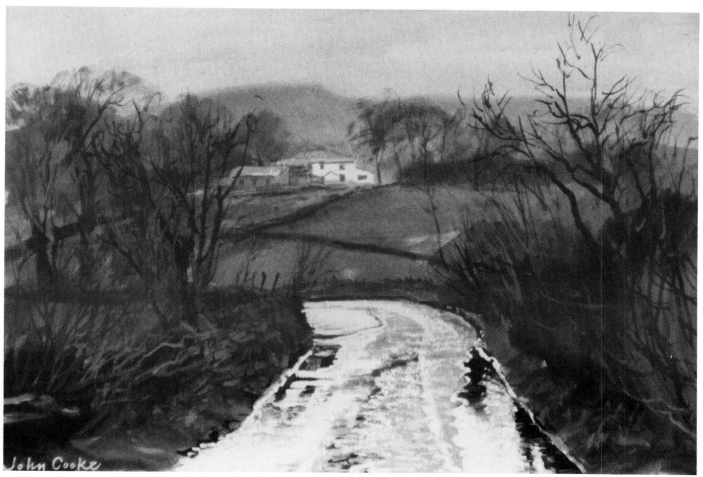

2 *Manor Farm, Dentdale, Cumbria.* Gouache on grey paper. $11\frac{1}{4} \times 16$in

from photographs has produced many unwarranted inhibitions which I will discuss later.

So, we have the reasons why we are attracted to water, something of its character and the way it absorbs the mood and atmosphere of the surrounding conditions, and the powerful effect it has had on artists in their efforts to describe the natural and man-made world. In the following pages I hope to explain how this effect has influenced my work and the way I go about making paintings in which water plays a signal role in expressing what I feel for my subjects and how, for me, they should be recreated in terms of paint.

Just to show you that waterscapes do not have to be sunlit lakes and rivers, I will start with a painting of a muddy road after rain. *Manor Farm (Figure 2)* might seem to be a most unlikely subject, but I found that the pools of water, collected on each side of the lane, caught the light beautifully and transformed a dreary landscape. Notice that all the light is in the road and the rest of the painting is subdued in order to express this (you will read later how I achieved this). I hope, however, this shows that waterscapes can be found anywhere.

CHAPTER ONE

The part water plays in landscape composition

Composing a picture is a two-way process. We see something which interests us and excites our imagination sufficiently for us to start thinking of it in terms of paint. Different things about the subject will be responsible for this interest: colour, lighting, shapes and subject matter all play their part in stimulating us. In landscapes it is often the arrangement of features and their shapes which strike us as having a pictorial quality and so, to a certain extent, the composition is already presented to us.

When a painting begins to form in our mind's eye, we probably look for the best possible arrangement of the features offered. We move around, for different viewpoints, from each side and perhaps from lower and higher vantages. Surprisingly the composition can be altered considerably by small adjustments to our viewing

position. Having decided on a viewpoint, the artist's contribution to the dialogue begins.

We start to relate what we see to the frame of the paper or canvas and, sometimes quite instinctively and subconsciously, we alter things slightly in order to make a picture. This may mean altering the sizes of objects. You may elongate a tree to suit its particular position in the composition; you may bring a stretch of water lower down to give it more prominence in the foreground; you may alter tonal values by darkening a shadow to accentuate the light; or you may make rippled water lighter in order to highlight it. Remember, we are not simply recording a view. We are making a painting, and this must have its own presence over and above the actual landscape.

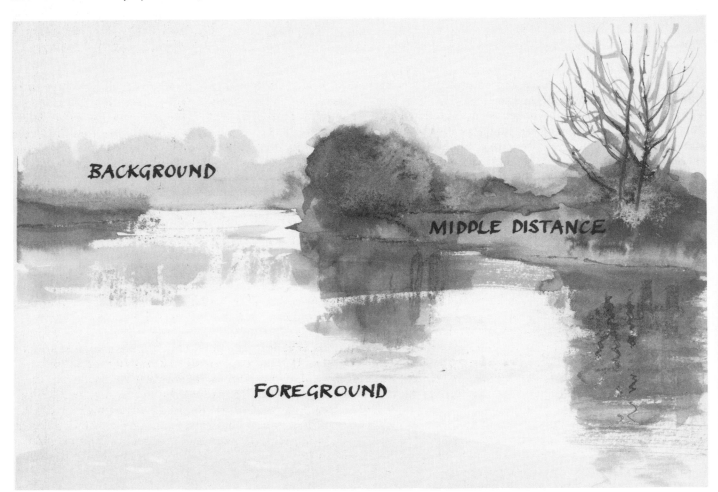

3 Foreground, middle distance and background

4 *Sun and Spray, River Dee, Dentdale*. Gouache on grey paper. $11\frac{1}{4} \times 16$in

As in the case of nearly all landscapes, waterscapes will have three stages of recession from our viewpoint. The foreground is where individual details play a prominent part. The middle distance is where things become more generalized and detail merges into larger features. Finally, the background is where only large features stand out, and we see the wider view of the landscape, in which our own particular foreground is a minor detail.

Figure 3 shows a simple arrangement of these three stages, starting at the bottom of our two-dimensional sheet of paper and moving up as we look further and further away. Note that, whereas the flat water surface of the foreground gives clear visibility to the middle distance, the trees of this second area are high enough partially to obscure the background. It would be an extremely simplified (and possibly boring) composition which allowed the whole of all three stages to be clearly seen. Also note that the water stretches back into the middle area meeting a patch of light between the two banks.

Consider the foreground of a painting. When water is a feature of this it presents a marvellous opportunity for you to introduce interest and excitement. The opportunity arises for you to experiment with reflected light, mirrored images and ripples, which all play their part in enriching the painting as a whole. The actual boundary of the water may provide shape to interact with the rest of the composition. Objects from the middle distance will appear as reflections in this water, either clearly or distorted, according to the state of the surface. Thus plain and otherwise uninteresting areas of foreground are enlivened and transformed into important parts of the painting.

Figure 4 (*Sun and Spray*) illustrates how water can introduce excitement and interest in the foreground. In the middle distance the water pours over a weir with a misty spray rising and catching the light. As it flows towards us it runs over some small rocks – a miniature set of rapids – and then levels out only to fall again over a couple of shallow steps. This area is treated very broadly with horizontal brush strokes of light on a medium tone, the darker tones being reserved for the rocks.

Nearer to us, the flow of the water is seen in more detail, with lines of light carefully tracing out the surface ripples. Darker tones are introduced into the water itself, particularly under the shadow of the overhanging tree to the right. Away left, more light and foam give a gradual shading across the foreground. Overhanging leaves make a counterchanging pattern of dark on light (left) and light on dark (right) to enhance the distance of the weir and the bridge.

The part water plays in landscape

Figure 5, *River Dee*, again makes an interesting foregound by contrasting with the snow and rocks to the left and introducing vertical reflections which weave their way through the horizontal lines of light and dark on the moving water surface. The water shades off from light to dark above the small rapids as our eye moves upstream. The horizontal-vertical interweaving is echoed in the upper part of the composition in the lines of walls and tree trunks.

In the middle distance quite a large stretch of water becomes foreshortened to give it the appearance of a long band of light across the centre of the painting. This may have reflections and some surface features, although smaller ripples will not be seen individually. Any part of this area of the painting may be obscured by objects in the foreground – for instance, tree trunks in front of the water breaking its line and producing more interest in a patterned form.

5 *River Dee, Dentdale*. Gouache on white paper. $11\frac{1}{4} \times 16$in

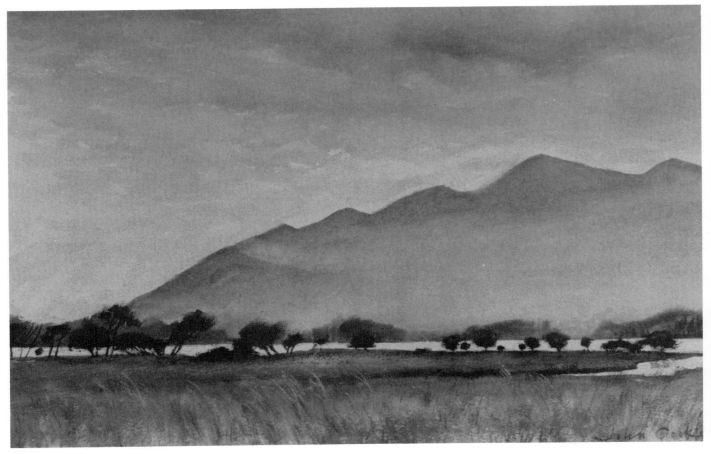

6 *Derwentwater, Cumbria.* Gouache on white paper. 11¼ × 16in

Figure 6 shows the whole length of Derwentwater (about 3 miles) contracted into a narrow strip across the composition. Although it has no reflections, the small trees and shrubs break up the line in an interesting pattern. Without this middle distance feature, the painting would have far less impact. The horizontal line also serves to emphasize the height and graceful line of Skiddaw, the mountain beyond.

The snowy landscape *Hugh Croft (Colour plate 1)* is again a horizontal band of water crossing the composition, but linked to the upper and lower parts by vertical reflections. It is painted in medium and dark tones with no highlights in order to emphasize the patches of sunlight on the snow in the foreground and beyond the river. This playing down of water tones when they appear in a snowy landscape requires a sensitive approach, and I shall mention this technique later.

It is impossible to lay down hard and fast rules as to where middle distance starts and ends. Being the demarcation between foreground and background, it may begin only 10 yards away, or a mile or more, according to the viewpoint and the strength of foreground detail. Similarly its transition into the background can be just as varied. It may even disappear altogether.

Figure 7 shows just such a jump, with the foreground figure and part of a boat placed immediately against a faint background of sea and coastline in the Greek islands. In this secondary role the water is no less important for being played down, and is still carefully considered, with light to medium tones being just right to complement the darks and highlights of the figure.

As a background feature water will play a much less important part in the composition, unless of course it is a large area of water like a large lake or the sea. Surface detail will be minimal, but it can still change tonally according to whether larger objects are reflected in it.

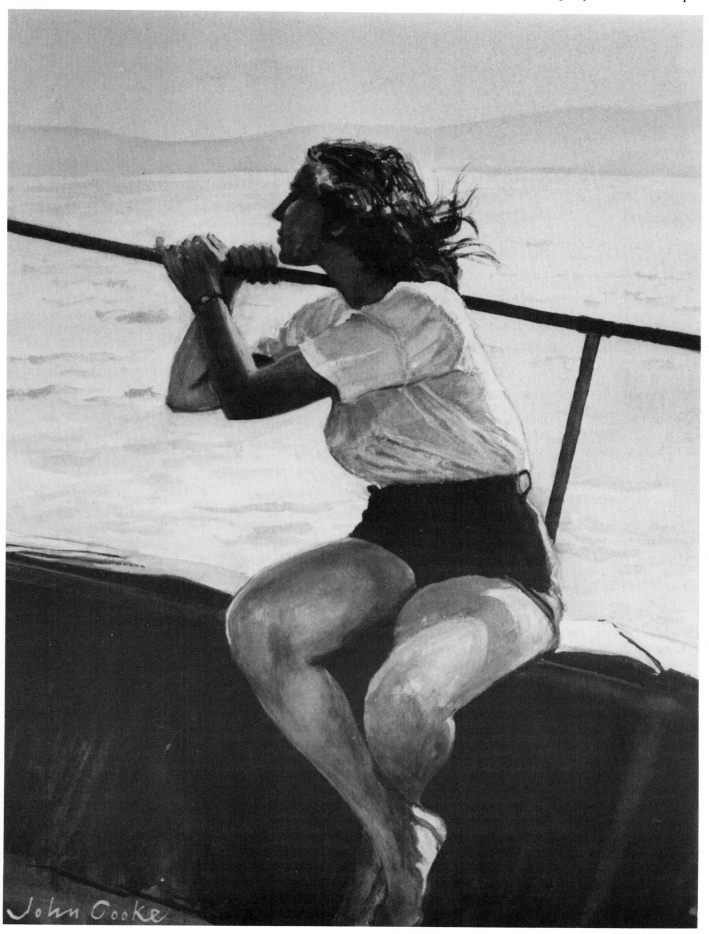

7 *The Girl on the Boat, Corfu.* Gouache on white paper. 20 × 14in

8 *The Sea off Brittany.* Gouache on white paper. 14 × 20in

The painting of the sea off Brittany (*Figure 8*) uses reflections of bright clouds and distant boats to give interest and a sense of distance. In addition, the cloudscape offers an example of background and middle distance in reverse, moving towards the viewer higher up the paper, as it is all above eye level.

Various types of water – that is, calm, rough, falling, etc. – can be used to make lively compositions or to add character and detail to already strong compositions. By this I do not mean adding water to a landscape which has none, although this has been done successfully by many artists who may indeed have created whole landscapes from their imaginations. All my paintings are the result of a personal experience of seeing something which strikes me pictorially and so, naturally, I am concerned here with painting actual places as they are, with a little arrangement to aid composition.

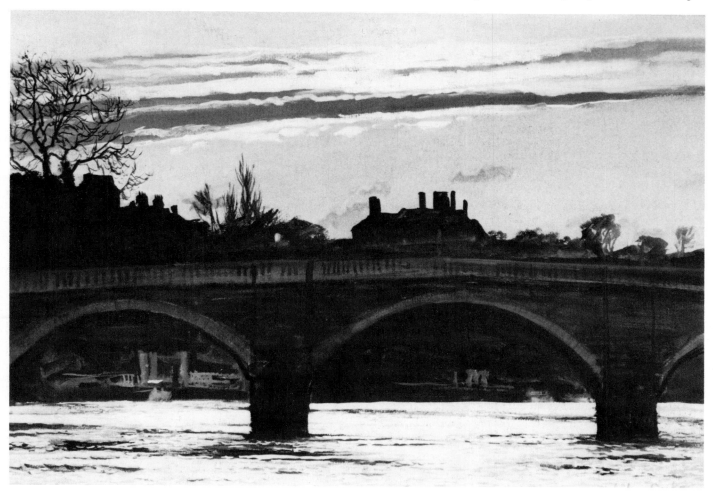

9 *Richmond Bridge, Surrey.* Gouache on grey paper. 14 × 20in

The painting of Richmond Bridge (*Figure 9*) has a relatively calm strip of water along the bottom edge. Its far edge is broken by the pillars of the bridge, thus avoiding a straight 'cut-off' across the picture. Above the broken skyline of trees and buildings, an almost straight line of clouds echoes this horizontality, albeit tilted at a slight angle upwards from left to right. This angle helps to give a sense of space by creating a perspective moving away to the left. The slight irregularities of the cloud belt are echoed in the little wavelets of the river, giving an interesting texture to both upper and lower parts.

The dark central area contrasts with a light sky and its counterpart in the water. A hidden sun, roughly centrally behind the clouds, makes this part brightest and, naturally, also its reflection. The two light bands above and below the bridge therefore shade off to either side. Notice that the slight detail seen in the bridge does the same thing.

A very different arrangement is seen in Figure 10. Scaw Falls, Dentdale, is a veritable Niagara in miniature. Its lip curves in the same way and the water pours over, to fall vertically some 10 feet, breaking against projections and steps on the way. Painted into the light, as you will have noticed many of my paintings are, the river appears as a narrow line at the far edge of middle distance. It zig-zags towards us, an effect exaggerated by perspective foreshortening, breaking a little over rocks, before flowing from left down towards centre. On the opposite side of the painting a few strips of light through the trees continue this line, not quite horizontal, but enough to delineate the curve of the falls' edge. The vertical lines of falling water are followed through upwards by tree trunks, giving an interweaving effect of vertical and horizontal lines (*Figure 11*). The river bank opposite joins the two main horizontals diagonally, all of these lines having sufficient character to avoid being too geometrical. In the bottom left-hand corner, sunlit blades of grass lead the eye away from an otherwise blank area to the falling water, in one place actually crossing it.

I chose the proportions of the three main areas of the painting instinctively. They could have been arranged differently and still been successful, but that would have been another picture. Indeed, you can stand in the same place and still produce a number of interesting compositions, although you might find this practice boring. I settled for this composition, and the choice of an upright format naturally followed the course of the water.

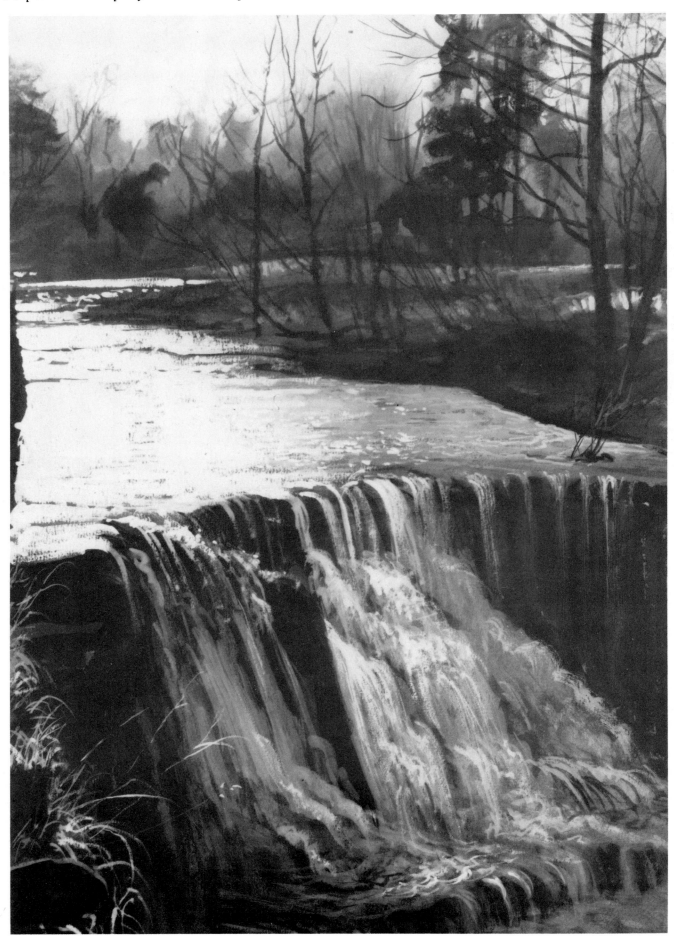

10 *Scaw Falls, Dentdale*. Gouache on grey paper. $19\frac{1}{2} \times 14$in

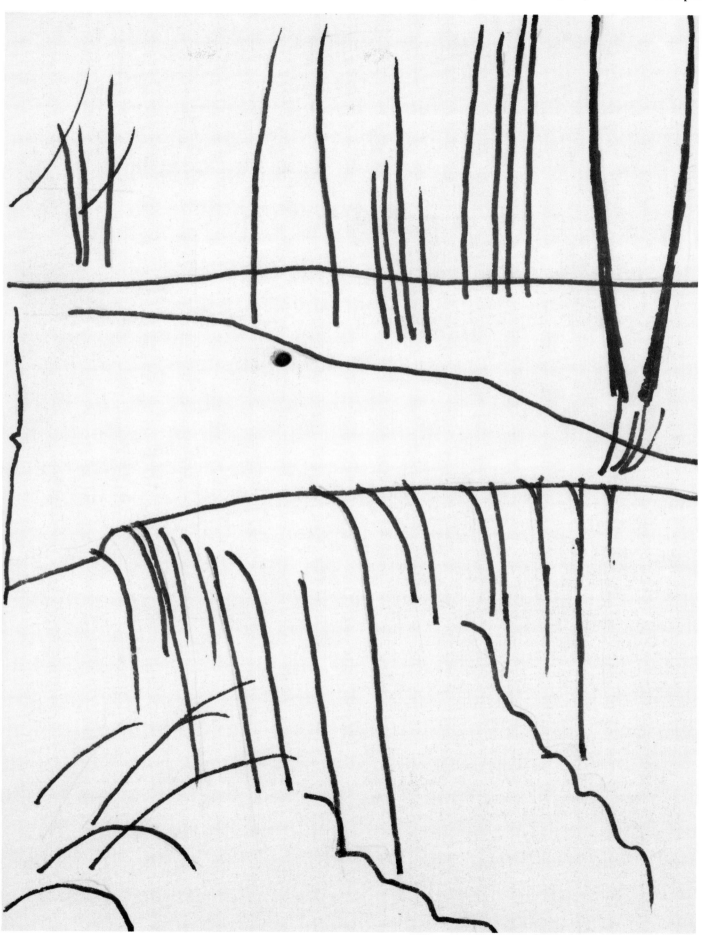

11 Compositional diagram of Scaw Falls

12 *Paleokastritsa, Corfu*. Gouache on white paper. $11\frac{1}{4} \times 16$in

Calm water is used as a background in the painting of a bay at Paleokastritsa, in Corfu (*Figure 12*). It depicts a distant line of sea, extending to the horizon in a counterchange of dark and light from left to right. I carefully painted the sky to show this difference in tone along the horizon, making it lighter than the sea to the left and slightly darker to the right. Brilliant light is reflected from a high sun way above the top limit of the picture. This change in tone, however, is partly an optical illusion: darkly silhouetted cliffs and trees, simply painted to make bold motifs, accentuate the light whilst also creating interest across the middle of the composition (although the cliffs belong to the background). The typical Mediterranean shape of the trees helps to give a sense of location. The foreground consists of dried grasses, again very simply painted, with a path on the right leading the eye upwards and inwards to the brightly lit sea. Although occupying only a small proportion of the composition, the distant water really completes the picture, imparting that sense of excitement which always comes with a first glimpse of the sea.

13 *Barth Bridge, Dentdale*. Gouache on grey paper. $11\frac{1}{4} \times 16$in

Barth Bridge (*Figure 13*) about a mile from my home in Dentdale, is placed centrally in the painting, its reflection in the calm water making an ellipse partially obscured to the left by a clump of trees, themselves mirrored in the water. Through the arch the riverbank can be seen curving round to distant trees beyond. A lane following the river brings this curve into the foreground, with tracks in the snow usefully leading the eye to this.

A shingle bank and shallow water occupy the foreground, the latter lying as a pool before trickling back into the main stream. A small puddle of melted snow lies in the road, but the main area of water dominates the middle distance, its flatness setting off the slight downward curve of the bridge parapet, the trees and the hill beyond. Although the river is reflecting light, the main tonal contrast is between snow and dark trees and shadow, these dark and light areas being arranged to balance with each other.

The part water plays in landscape

Now we come to the use of rough water in landscape composition. This is perhaps the most difficult of all types of water to portray; its general confusion hides the underlying pattern and form which water must have. The water depicted in Figure 14 sweeps smoothly from the centre background, under the middle distance bridge to pour over a weir, which is positioned at a slight angle to our line of viewing. This angle helps to indicate the curve of the river as it sweeps towards bottom right of the picture. From then on the foreground is filled with a turmoil of waves and foam which at first sight have no organization whatsoever. On closer inspection, however, you can see that this is not so. On the near side of the weir the water swings round from left to centre, descending as it does over an uneven bed, to rejoin the main flow from the weir. This is indicated by lines of light following the direction of flow or sometimes indicating waves across this direction. As it falls over the last step it curls up back on itself, breaking into foam and steeply pitched waves, producing the very light area at bottom right. This light mass is counterbalanced by dark trees at top left. Remember, both light and dark can have weight in a composition. Above hang branches which have the same quality of line and texture as the rough water, helping to impart a feeling of unity to the painting as a whole. The bridge is a notable contrast, in its regular lines and curves, to the exciting freedom of trees and water.

14 *Millthrop Bridge, Dentdale.* Gouache on grey paper. $11\frac{1}{4} \times 16$in

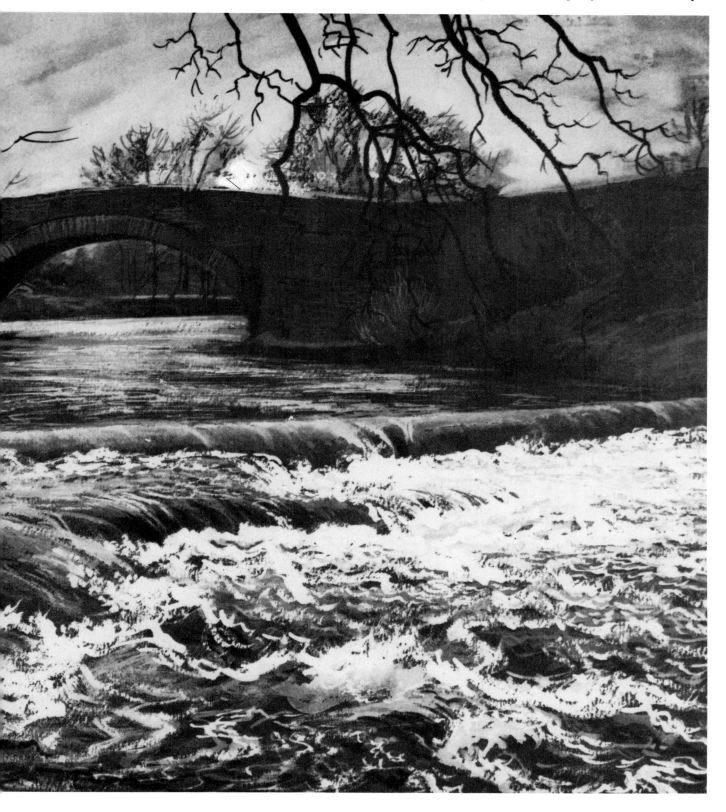

15 *Windermere, Cumbria.* Gouache on white paper. 14 × 20in

Windermere (Figure 15), in contrast, has a large expanse of calm water occupying the entire lower half of the painting. It stretches in a level sheet over foreground and middle distance to a background of low hills, whose gentle undulations echo the exotic arabesque of a dark tree outlined across the top foreground. Branches on the left evoke the foreground that we know is below the painting.

Across centre the water's far shore seems to move away to the right because of the lighter tone of the hills in that direction. This straight line acts as a foil to the tree and is itself crossed by three verticals – the masts of boats placed in the blank area partly framed by the tree. Their position below the dark mass of leaves and branches helps to create an illusion of floating.

This painting is a good example of the way in which you can suggest water with very few brush strokes, a few faint ripples in the foreground and distorted reflections below the boats being the only marks on otherwise blank paper.

Composing a picture becomes instinctive, but it does require some forethought to avoid a clumsy arrangement of features. The Victorians cut rectangles in cardboard to view the landscape through, or carried mirrors; you may find this a useful way of seeing landscape as a picture, until practice supplies the imaginary frame of the painter's eye. If you imagine a fulcrum placed in the centre of the bottom edge of a picture, it should feel comfortably balanced at this point. This does not mean that it must have an all over evenness – some of the most exciting compositions have a mass of concentrated detail to one side, balanced by great spaces at the other. It all depends on the colours and tones used and the values given to empty areas of a composition.

I reproduced each of these compositions as I saw them, altering only a line or tone instinctively to produce the optimum effect. The most important decision came right at the beginning in mentally arranging a frame around what I saw to create a picture.

CHAPTER TWO
Perspectives of waterscapes and various viewpoints

The fact that extensive waterscapes, such as lakes and the sea, present a level plane unusual to most landscapes, makes attention to surface perspective very important. Most people do not realize how much of the surface area is contained in the narrow distant strip, and therefore how rapid is the recession of the first small fraction. A telephoto lens will produce pictures showing little change in size in distant objects far apart from each other, whereas nearer to, a smaller difference in distance produces very notable changes in apparent size.

With water we have the advantage of painting a reasonably regular size of surface detail. If it is calm, most ripples are about the same; if rough, the waves have the same regularity unless disturbed by some local feature. This means that if they appear smaller, the waves are almost certainly further away; this would not be the case for small rocks protruding from the surface.

Look at Colour plate 2, a little painting titled *Distant Albania*. It shows the Straits between Corfu and Albania from Ipsos Bay. From the foreground the waves and sparkling light diminish in size as we look further away. The headland is not more than a quarter of a mile away yet the water occupies most of the painting. Approaching the headland the light is reduced to a textured scumbling with a dry brush. From there on the marks are about the same size and would appear so if photographed with a telescopic lens. The first mile takes us approximately up to the thin strip of distant light, and this contains the remaining 5 miles or so to the Albanian coast. Another thing to realize is that, standing on a jetty as I was, I

16 *Falls below Cowgill*. Gouache on grey paper. 16 × 11¼in

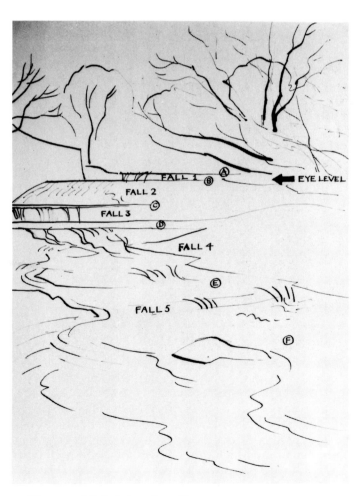

17 Diagram of Falls below Cowgill

18 *River below Cowgill, Dentdale*. Gouache on grey paper. 14 × 20in

looked down on the nearby water, but as my gaze lifted towards the distance, the angle became less and less pronounced so that a greater *foreshortening* took place.

Tonal perspective is evident between the headland and the distant hills. This is due to the viewer looking through a volume of air which tones down both light and dark. The sea does not show this tonal muting, partly because foreshortening can affect the appearance of tone and partly because the brilliant reflections will hold their own

against distance. However, I deliberately intended to keep the contrast going between dark waves and highlights in order to maintain the sense of light.

The perspective of falling steps of water can produce interesting problems. In Figure 16 the river descends towards us in shallow steps from the distant waterfall to the nearby pool. The levels are listed A to F in the diagram (*Figure 17*) with eye level at level B, so that this plane of water and the one above it are out of sight. Fall 2

In reverse, if we are looking downstream the problem is accentuated and many of the lower levels will be partially hidden. I have not found that this makes good subject matter for a painting (or am I just avoiding the difficulty of suggesting water running away from the observer?). It can be seen in the winter painting (*Figure 18*) where nearby water disappears over a fall to reappear at a lower level. How successful I was at portraying this I leave to your judgement. Diagramatically the problem is described in Figure 19.

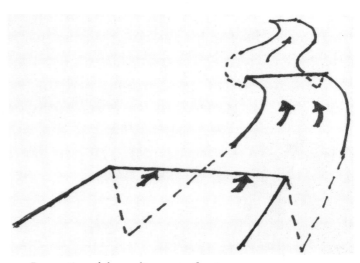

19 Perspective of descending water flowing away

descends more gradually, and we see level C as a narrow, foreshortened strip. Fall 3 is more abrupt and the following level D still foreshortened but less so. Fall 4 is gradual again, running into level E which we can see in greater detail than the others, not simply because it is nearer, but because it has reached a level at which we can look down upon it. The small step at Fall 5 brings us to the final level F where all is revealed.

Perspectives of waterscapes

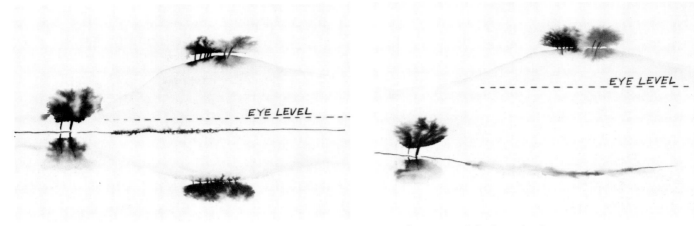

20 Reflections with low eye level

21 Reflections with high eye level

22 *Mirrored Reeds, Tarn Hows, Cumbria*

23 Distorted reflection from high subject

24 Reflection from high viewpoint

Reflection can be a problem owing to the varying nature of water surface and to the position of the object being reflected. This latter point is shown in the two diagrams, Figures 20 and 21. In Figure 20 we are standing at water level with an eye level where a person would be similarly situated on the opposite bank. Trees on the shore are reflected in full as are the trees further away and higher up. Slightly less of the hill is reflected because the mirroring begins at eye level. Viewed from a hill (*Figure 21*) with our eye level now raised to the distant trees, the shoreline trees still show their reflections, perhaps a little shorter, but the higher ones are now beyond the limit of reflection. In more detail, Figure 22 shows nearby reeds completely mirroring themselves in still water. The distant lake is catching light and is thus too bright to allow reflections.

The house in Figure 23 is further from the water and higher up; consequently only its roof shows as a distorted reflection in moving water. The same applies to the tree in Figure 24, but this time owing to our own higher eye level. An effect of distance only from the water, rather than height, can be seen in my painting of the River Dee used by Royle as a Christmas card (*Figure 25*). The two dark trunks below the sunlit bank are fully reflected. The figure is further back on the snow and misses the reflected area altogether.

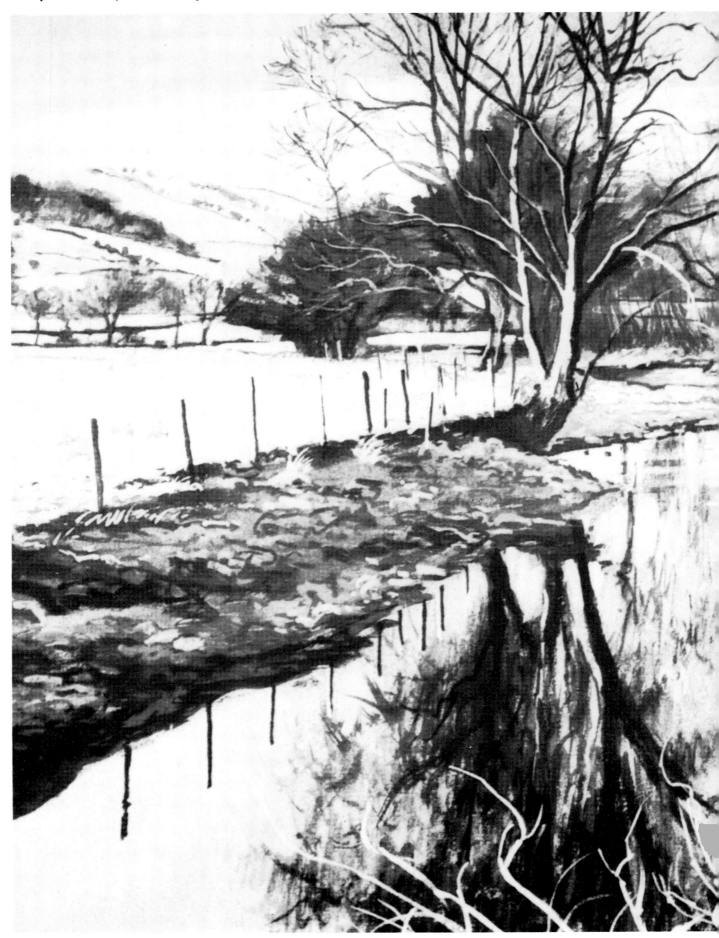

25 Distant figure missing reflected area. Royle Christmas card

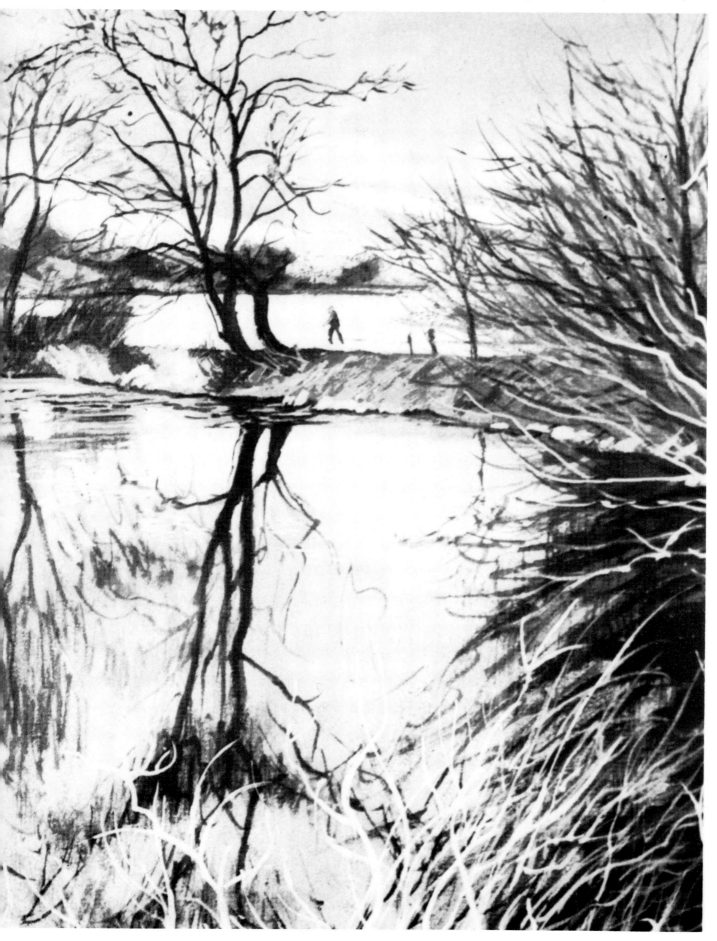

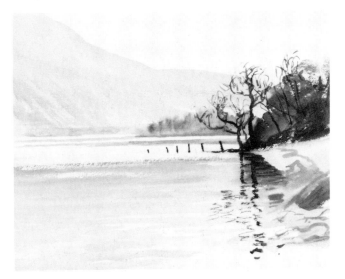

26 Light cutting out reflections. *Wastwater, Cumbria*

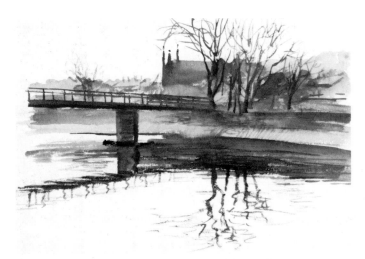

27 Obstructed reflection, *Church at Kendal, Cumbria*

The slightest disturbances can affect reflections. The little sketch of Wastwater (*Figure 26*) shows trees at the water's edge fully mirrored. However, a little to the left, a breeze disturbs the surface, creating small ripples which reflect a dazzling light. Consequently, the posts descending into the water have no reflection at all. In Figure 27 a dark reflection from the built up river bank completely prevents any image which might have shown from the church, which is present as a dominant shape on the skyline.

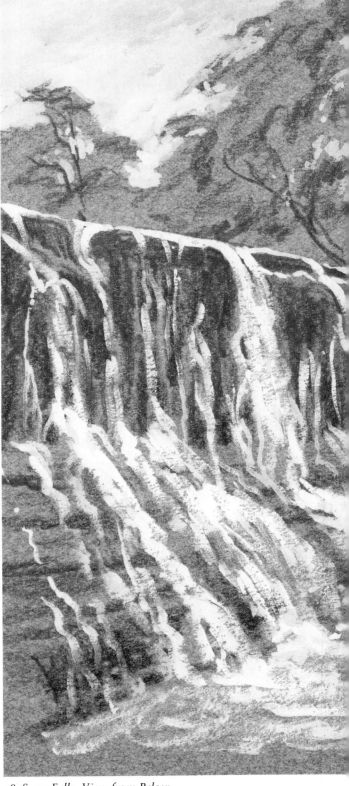

28 *Scaw Falls, View from Below*

Another point of interest is the way in which different viewpoints affect not only composition but the whole aspect, including perspective, of a feature we are painting. Scaw Falls (*Figure 28*) are about 10 feet high and elegantly curve around a step where hard limestone covers softer shales. I described these in the chapter on composition as a miniature Niagara and seen from below

they can be quite dramatic despite their diminutive size.
In Figure 28 our own eye level is below the lip of the falls,
and so the river upstream is hidden. The water spills over

29 *Scaw Falls, View from Above*

gracefully and the perspective of lip and base alert us to the sweep of its face. A background of trees and hillside plays a very subdued part, though making an interesting foil to the level foreground. Seen from above, perhaps 15 feet higher, but about the same distance downstream (*Figure 29*), the upper river comes into view as well as some smaller falls in the distance. The background is still subdued, but we are more conscious of the surroundings of the falls than we are in the previous drawing. Painted at a different time, the river is also more full and the falls are more powerful.

Walking forwards a few paces we turn and look along the lip of the falls (*Figure 30*). Here the face is almost lost to view, and only the far curve gives us an idea of that dramatic first view. We are more conscious of the water pouring over the lip than the elegant cascades over the face, and as the falls are foreshortened the background plays a much more important part.

This is an almost limitless subject as all waterscapes offer perspectives and viewpoints peculiar to themselves. I hope the few examples I have given will suggest ways of solving these problems as they arise.

John Cooke

30 *Scaw Falls, View Across*

CHAPTER THREE
Using various media

Visitors to my studio often ask me which is my favourite medium. I trained as an oil painter but find that there is greater demand for works on paper. As a result I have frequently used gouache, a water paint which closely resembles oils. Yet my answer to the question is that I enjoy variety. It is refreshing to move from one medium to another, preventing staleness. You can work in a single medium without ever becoming repetitive, but as I paint many landscapes with similar qualities a change of medium stimulates and in turn encourages development.

Oil paint is a very forgiving medium in that errors of judgement can be corrected by scraping off surface paint and simply starting again. If done too often this results in a rather muddy area, and you may have to let it dry before trying again, Various quick-drying vehicles are available such as 'WinGel' thixotropic oil painting medium. Painting with varnish is another way of cutting down the drying time. It gives a lustre which saves having to varnish later. I sometimes use this method, but more often use the paint directly from the tube. This dries with a matt finish so you have to decide whether to varnish it or not. In addition, when painting water much depends on a free, direct brush stroke and oils tend to make you less inhibited as you know you can always try again.

Knaresborough (*Figure 31*) is an example of a waterscape in oils. I worked on it intermittently for several weeks, allowing it to dry and attempting to see it with a fresh eye each time I returned to it. It has a rather complex background with the light source coming from over and under the bridge. The houses were carefully

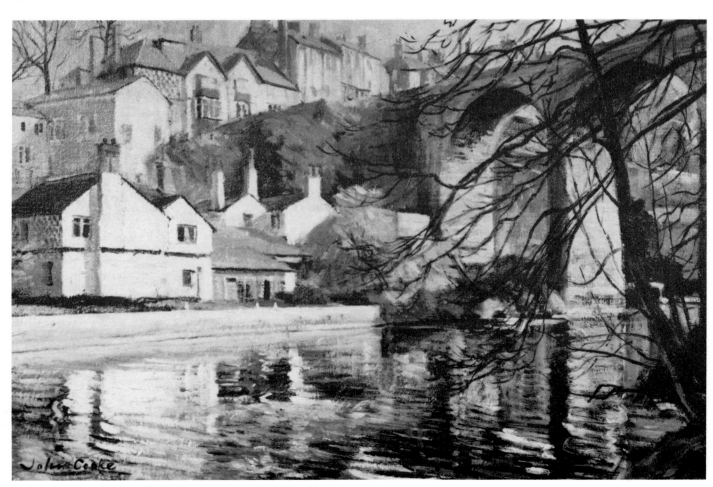

31 *Knaresborough, Yorkshire*. Oils on canvas. 18 × 24in

modelled, with light coming from the right, and Cobalt Blue used in the shadows.

As it was early spring, the trees were only just in bud and I used a palette of Indigo, Burnt Ombre, Cobalt Blue, Winsor Green, Yellow Ochre, Raw Sienna, Terra Rosa, Titanium White and Ivory Black – a rather full palette for me as I usually rely on a much smaller range of colours. I tried to maintain continuously a fresh, clear light. The Cobalt shadows and Sienna and Ochre light, especially on the water, worked well with each other in their contrasting coolness and warmth. As the painting progressed, it was possible to scumble neat paint over the dry, uneven surface.

The near building is actually strongly chequered, as are many Knaresborough houses, but having done this I decided it detracted from the composition and painted the facing wall white, with only a hint of chequering in the side wall. I felt the resulting light justified this alteration. In addition to large bristle brushes and a nylon oil brush, I used a small sable (No. 2) on windows and some of the branches. Most of the water brush strokes follow the surface, curving away left, but a strong vertical element is retained in the reflections depicted by these marks.

Knaresborough was painted on canvas, but this is not the only ground suitable for oil paints. Paper and board are both pleasant surfaces to work on though they do not have the 'bite' of a textured canvas surface. They can be sealed with a coat of glue size or used untreated; in the latter case you can draw the oil from the paint, giving a scumbled texture to the brush stroke. Most of my student paintings were done on these much cheaper materials, and I still use a 4-sheet board for oil sketches.

For *Womack Water* (*Colour plate 3*) I used a mid-grey board and allowed this ground colour to play a part in the finished work. I used to live in East Anglia and was always conscious of its clear light, the result of an almost continental climate. The Broads are a particularly attractive part of it, with tree-lined waterways interlacing level landscape. There I found it impossible not to think of the Impressionists as I painted water and boats.

The surface of the board was unprimed, and I used the softer nylon brushes (No.8 and No. 2 chisels), these being more sensitive on an absorbent surface. I thinned the paint to begin with, using a turps and linseed oil mixture. This time I included Prussian Blue on the palette, a good colour for mixing greens and for summery blues when lightened with white.

First I painted in the sky up to the treetops, the only drawing being a line automatically made by the edges of the paint. On down through the trees, I emphasized light, striking from the left in bold brush strokes of Sienna, and suggested the boats by a few lines while the water was painted in. The Impressionist look is probably due to the even brush strokes placed quickly without any later tidying up. The colour, however, is rather quiet, and the tone is crucial, as opposed to the Impressionist characteristic of being chiefly concerned with colour relations.

I painted the boats in with the same quick strokes, taking care with tone and colour to suggest water reflecting on hulls and darkening the cabin interiors. Lines of light down each of the bows, a touch of warmth

in cabin timbers and their reflections and the upright mast are important foils to the cool horizontals of this painting.

As mentioned earlier, I sometimes use varnish to thin oil paints (retouching varnish is suitably fluid for this purpose), and the paint dries with a built-in gloss so that further varnishing is unnecessary. With paint thinned with turps or paint straight from the tube, you get a matt finish, which may look perfectly right in certain cases. It does mean, however, that tones and colours are slightly subdued and if the contrast is lacking, a coat of picture varnish, applied after the paint is completely dry, will lift colour and tone back to the level at which they were applied. The same effect as varnishing can be seen when a sheet of glass is placed over a gouache or water colour. (This also applies to acrylic paint for which a special varnish is available. I am not certain how essential this is, however, as I usually find the matt finish of acrylic attractive.)

Acrylic paint is something I turned to relatively recently. I like its quick drying capability – a decided advantage when a space on the studio wall needs filling. I use it in the same way as oils so in my work it is difficult to differentiate between them, although the hues of acrylic paint are different. I often use canvas but sometimes prime plywood with emulsion paint. (Purpose made acrylic primer is available.) I like the resistant quality of the ply and its slight graininess. It is resistant to distortion and lighter than hardboard.

I have done a number of paintings for Shell calendars and when asked to do a couple on the theme of wildlife habitat, I decided to use acrylics for one of them. I was given two types of habitat – moorland and lakeland – and for the lake I chose Little Langdale Tarn (*Figure 32*), a beautiful stretch of water surrounded by mountains in the Lake District. Its reed-covered banks ideally suited the requirements of the brief.

I underpainted primed plywood in a blue-grey at the top changing to a warm brown at the bottom. Using sable brushes I worked as usual from sky and background forwards, only outlining shapes with the edge of colour rather than with a line. I lightened the sky with white, allowing blue-grey background to show through and modelling mountain form with blue-brown mixtures and Sienna sunlight. The high snow helped to express details of ridge and gulley. Trees on the far shore suggested scale and distance, and the water plane gave an exciting sweep up to the mountains. An eye level about two thirds up the composition allows more space for the water making it a lake rather than a mountain painting.

White horizontal strokes indicate a wind-ruffled surface, broadening as they approach and finally resolving into lines of wavelets. The foreground stones and mud were painted in last, making use of the brown background. Reeds were indicated with a fine brush – gouache is easier for this than acrylic – with the usual counterchange of light on dark, dark on light applying. You can see the horizontal–vertical direction of brush strokes typifying the treatment of calm water as opposed to the free directional strokes elsewhere.

It will be obvious from this book that I use gouache more than any other medium. Its similarity to oils and its

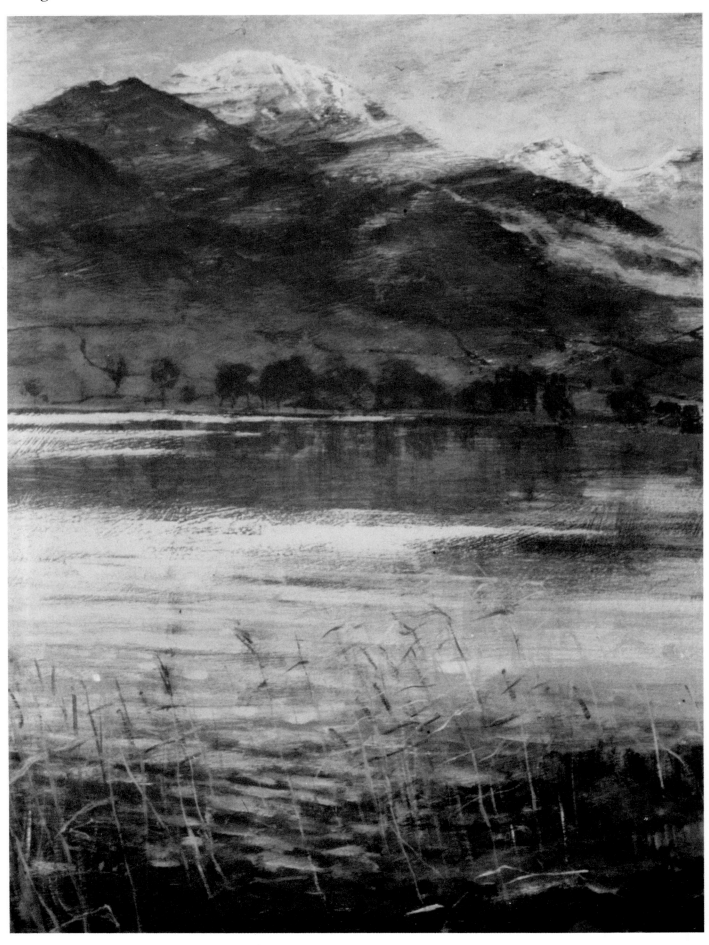

32 *Little Langdale Tarn, Cumbria.* Shell calendar. Acrylic on ply. 29 × 26½in

quick drying ability both have their appeal, but I also discovered an unsuspected versatility from which I get tremendous pleasure and satisfaction. Its flexibility over a range covering thin translucent washes to heavy opaque colour, with paint taken directly from the tube, means that you can use a variety of techniques in the same work. The watercolour technique is ideal for painting softer backgrounds, to suggest either distance or a hazy atmosphere, while the crisper oil technique gives an immediacy to the foreground (see Figure 93).

As a bodycolour, gouache can be used on tinted or white paper. On the mid-tone, all light comes from the paint itself, but on white paper this can be allowed to show through the paint as in watercolours. There is an important difference between these two grounds in using thin washes. On grey paper, for instance, thin washes of light colour became *darker* as the paper shows through, not lighter as on the white paper. This may be confusing to begin with but with practice results in quite unusual effects peculiar to gouache paint.

I have tried various papers over the years and find that a smoother textured paper suits my style of painting best. I use a Bockingford 140lb white watercolour paper (which I sometimes tint before use) and a mid-grey Mi-Teintes Canson paper. This is double-sided, one side being smooth, the other having a slight texture which holds water nicely when laying on washes.

I never stretch the paper as its thickness helps to prevent cockling, but I fix it down with adhesive tape onto the board after having trimmed it to just over picture size. I lay the adhesive tape carefully, covering the paper edge by about $\frac{1}{8}$in. When the painting is finished, this can be carefully peeled off, by pulling at right angles to the edge and level with it, without damaging the paper. This leaves a neat white or grey border round the picture which can then be mounted directly onto board with doubled gummed paper or a photo-mount adhesive. If preferred, there is still enough paper beyond the picture edge to place behind a cut mount. Any tendency for the paper to cockle during painting quickly disappears owing to the taped edges. This is a method of mounting I have devised which can then be slotted into a metal kit frame for display in the studio. The work can easily be removed for anyone preferring a more conventional method of framing.

The painting *Frozen River* (*Colour plate 4*) is a winter view of the River Dee done in gouache on grey paper. Wintery days like the one shown here produce very dramatic effects, with a low sun glinting on ice and water. The grey paper makes a good contrasting background for white gouache.

I washed the sky in with a Permanent White, thickening the paint towards the horizon where more light was needed. Behind the trees I allowed paper to show through with a drier brush, blending the greyness in later on as the

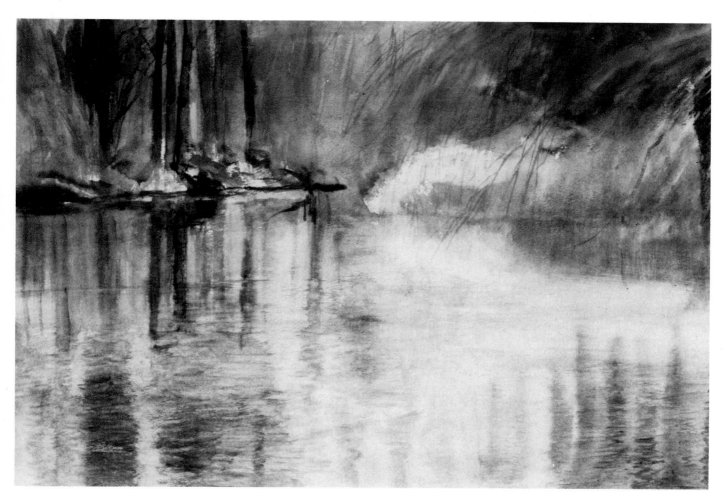

33 *Pond in Bushy Park, Middlesex*, Stage 1. Gouache on white paper. 14 × 20in

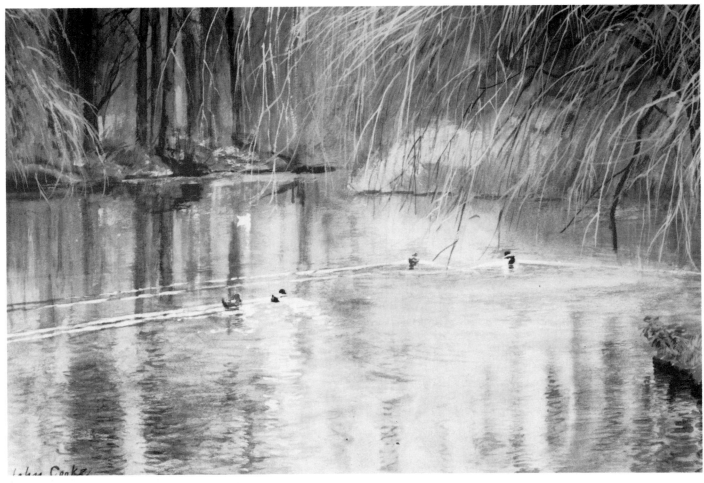

34 *Pond in Bushy Park*. Stage 2

trees were painted. The hilltop was carefully outlined with this white and, when dry, I painted the hill in with Cobalt and white, adding a touch of Burnt Umber as darker features appeared.

While the sky was drying I sketched in the position of walls, road and river with a small brush and a thin mixture of Indigo and Burnt Umber. I find these colours admirably serve to make anything from a pale grey to a rich blue-black and can be weighted on the warm or cold side by varying the mixture.

Once the sky was dry and the hill painted in I put in the central group of trees with a No. 8 sable brush, softening the edges a little with water to avoid a hard outline. Next I put in the nearer trees changing to a No. 2 Daylon brush for smaller branches which merged with the grey paper I had left showing. These two brushes are my main standby. Sable is undoubtedly the best for holding water while keeping its shape, and a new No. 8 brush has a point capable of very fine work combined with good spreading ability. A No. 2 Daylon brush is too small to worry about holding water and it retains its point longer than sable. I sometimes use a large bristle brush (about No. 16) for larger paintings and have done complete gouache compositions with bristle brushes where a broader treatment was desired. I also use a No. 2 wash brush for dampening the paper before painting.

Returning to *Frozen River*, I added some brown and Raw Sienna to the sloping land on either side, toning it down with a little Indigo where uneven ground showed

through the snow. I darkened the road with Alizarin Crimson and Indigo and used brown and Indigo on the retaining-wall. As soon as I started to paint in the snow the picture came alive with light. I had to be very careful not to overdo this because I wanted the focus of light to be on the water and so as I painted nearer to the river I toned down the white slightly with Cobalt Blue and a touch of Burnt Umber here and there. In places the grey paper still showed through, adding to the effect of rough ground and stones. On the top of the foreground wall I lightened the white again to bring the wall forward. The river ice was kept to the same low tones except where light reflected brilliantly. Here I took no half measures and used a thick white, tinted warmly with a little Raw Sienna, and blended this into the very dark Indigo-Umber mixture under the trees, where the unfrozen surface needed some vertical reflections.

As with oils and acrylics, with gouache the light comes from the paint itself. Where the paper shows through it has the effect of toning down light and helps to give a unity to the painting. Using white paper with gouache can call for a water colour technique, although the paper can be toned down with washes and then overpainted with lighter colours.

Pond in Bushy Park (*Figures 33 and 34*) is done in gouache on white paper. Near to Hampton Court and my mother-in-law's home I have walked through the park quite often. It epitomizes the tranquility which can be found amongst an urban environment. The first stage

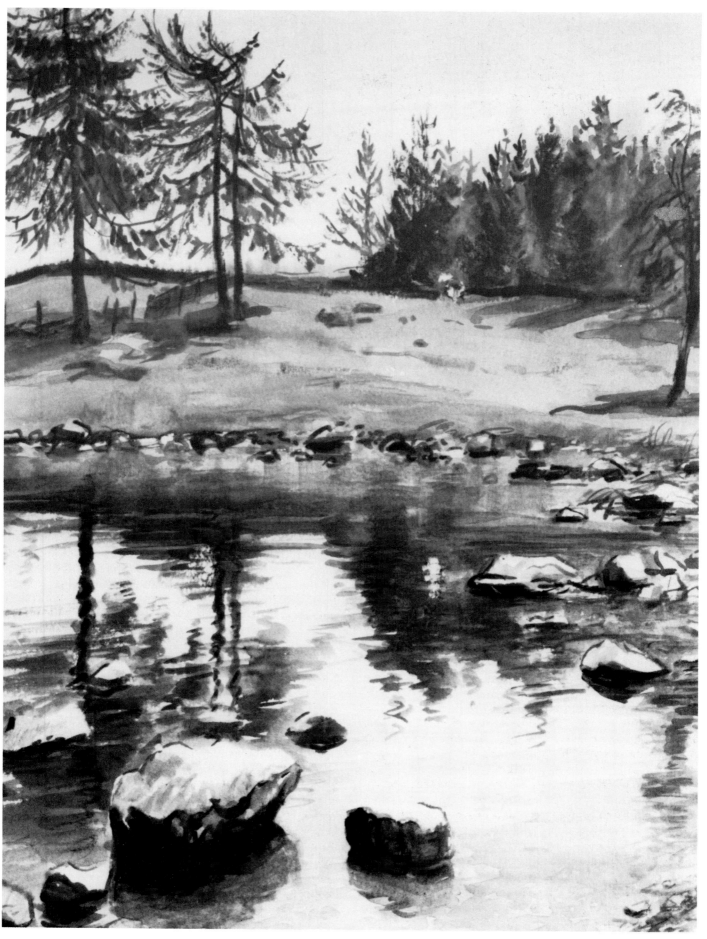

35 *Blea Tarn, Cumbria.* Watercolour. 16 × 11¼in

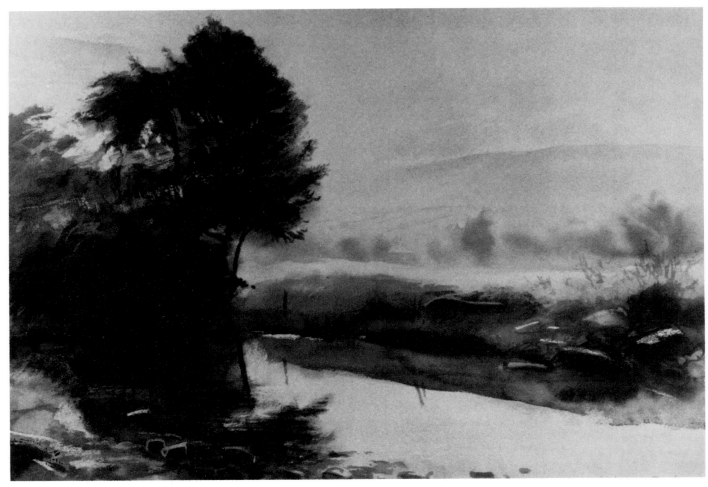

36 *Misty Day, River Dee, Dentdale.* Gouache and wax. 14 × 20in

shows how I covered the paper with under-painting, not as a flat wash, but by carefully drawing in shapes and details in varying tones, keeping light areas of Raw Sienna and introducing grey-greens and browns into the darker parts. The brush marks suggest tree trunks, water surface and a nearby willow.

Stage two shows overpainting in thicker paint at both the dark and light end of the tonal scale. The ducks, their trails, more precisely drawn trees and vegetation, and the willow branches are all part of this stage, but the background luminosity comes from the earlier blending of watery washes with the white paper showing through. This mixture of oil and watercolour techniques is possible only because of the versatility of gouache. Early watercolour painters sometimes used white body colour to lighten the paint, but gouache has a much stronger covering power, while being very transparent if used as a thin wash.

The defition of specialization is learning more and more about less and less. My preoccupation with gouache and oils means that my water-colour technique is rather neglected and so when using this medium I often find I must resort to body colour or scratching through to the paper. However, *Blea Tarn* is a watercolour I was reasonably successful with (*Figure 35*). I had two main objectives in this work: to express the surface of the water and to show details seen through it.

I used Lemon Yellow and Prussian Blue to provide the greens, and Indigo, Cobalt Blue, Alizarin Crimson, Burnt Umber and Raw Sienna for rocks and sunlit water. The tarn bed was painted in subdued pinks and blue-greys, allowing paint to run a little to give a slight indistinctness. I put the shadows and reflections in much more stongly and sharply, in contrast to the stones beneath the water. A few lines marked out the tops of nearby boulders against light water, but I avoided completely outlining them as this would have given them a cut-out appearance. I removed some of the colour with a clean brush and water just under the far shore, using short vertical strokes to give the reflection of the sunlit bank; I also scratched the surface slightly with a sharp knife to bring some light through the trees and their reflections.

Instead of scratching through or using white body colour, a resist can be used to retain the white of the paper. This may be a clear wax (an ordinary candle is ideal) or a liquid rubber which, when dry, can be lightly rubbed off. Copydex can be used for this or a purpose made resist such as art masking fluid. The effect of the rubber resist can be seen in *Anglesey Coast* (*Figure 37*). Without any previous drawing, I brushed on Copydex where waves broke approaching the shore and foamed against the jutting rock. In the foreground I indicated grasses, and for their thin stems trailed a line of Copydex onto the paper without the brush touching. Use an old

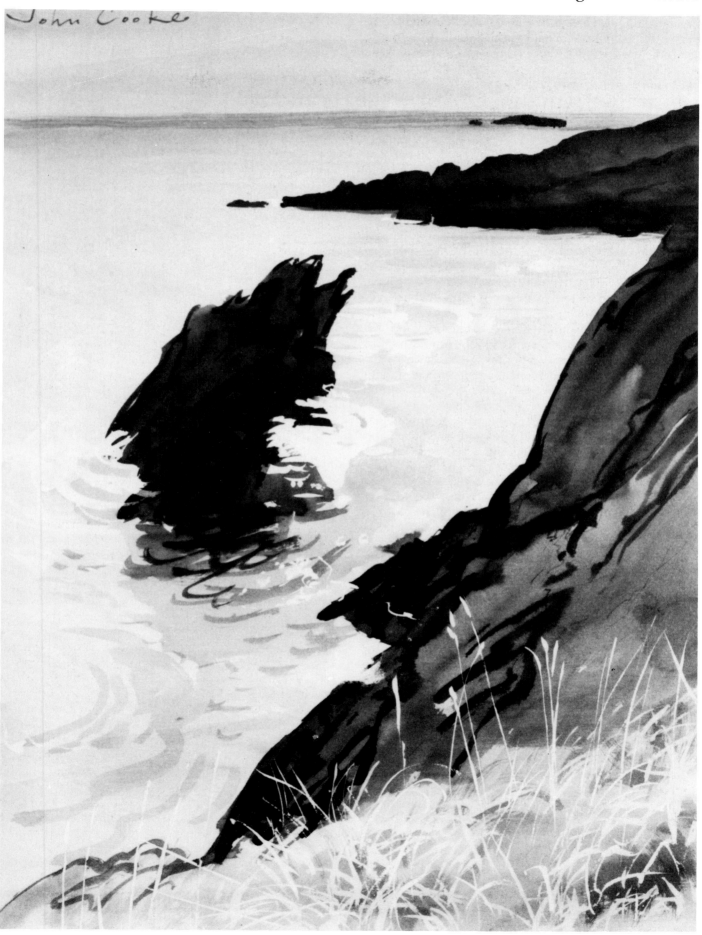

37 *Anglesey Coast, North Wales.* Inks and resist. 20 × 14in

Using various media

brush for this as it has to be expendable! I applied green, brown and red inks with pale washes, gradually working up to the darker tones. Once all was dry, I removed the resist by rubbing gently with my finger tips, exposing white paper underneath.

This method produces a white area with a clean edge. If a texture is needed then wax is the answer. Resists are waterproof, preventing the paint from touching the paper, but wax – like crayon – has a grainy texture that allows little blobs of paint to settle in it.

Misty Day (Figure 36) has wax drawn in at various stages so that in places it retains the white paper, in others the colour it was drawn onto. I wanted the painting to have a delicate misty look and so was quite sparing with the wax, which can be a little crude if overdone. I used it to give texture to the water near to the tree reflection, to highlight the tops of stones and to show light through the trees. The tops of both banks and some stones show wax on a colour and there is a little scratching in the trees where some extra white was needed.

The pen is an exciting instrument to use, its well defined outlines adding crispness and the opportunity to give a very personal handwriting to a work. It will show up details where tones do not have enough contrast to do this, but you have to be very careful not to outline everything in the manner of a child's colouring book. I prefer a flexible steel nib, giving thin or thick lines according to the pressure used. I have used Rotring and ball pens, but their line has less character although they are very convenient for outdoor use. Some ball pens have a water soluble ink which runs into the washes in an interesting way, but it does tend to fade.

To avoid the pitfall of too much outlining it is a good idea to leave the penwork until last. This is a case of 'do as I say not as I do' because I often draw with the pen first of all, but I have to have a clear idea of the finished work in my mind to keep it to a minimum. If you can do this you can draw out of doors and colour wash in the studio.

Snape Quay (Colour plate 5) was drawn in first with sepia ink (less emphatic than black) and then colour washed with gouache. All the light comes from white paper, and the toned down sky emphasises the light water. The pen line aided the clarity of the scene with its calm water and clear reflections. The details of the boat are picked out against medium tones while the dark tones hide the line almost completely. A little pen drawing was done later to strengthen the reeds.

Black and white drawing has a charm of its own as well as being a valuable exercise in tonal relations. In Chapter 6 I describe the necessity of sacrificing contrast at one end of the tonal scale in order to enhance the other. I started *House in Kentmere (Figure 38)* with the brush and much diluted Indian ink, freely indicating trees without covering the paper too much. I gradually strengthened the ink until a full tonal range appeared. I used the pen last, allowing some to run into the wet washes. The trick is to know where to use tone and where to leave it out. The nearby shingle and some of the background foliage would not really be as light as the drawing suggests, but any tone on them would lose the sense of contrast which

38 *House in Kentmere, Cumbria*. Pen and ink wash. $10\frac{3}{4} \times 13$in

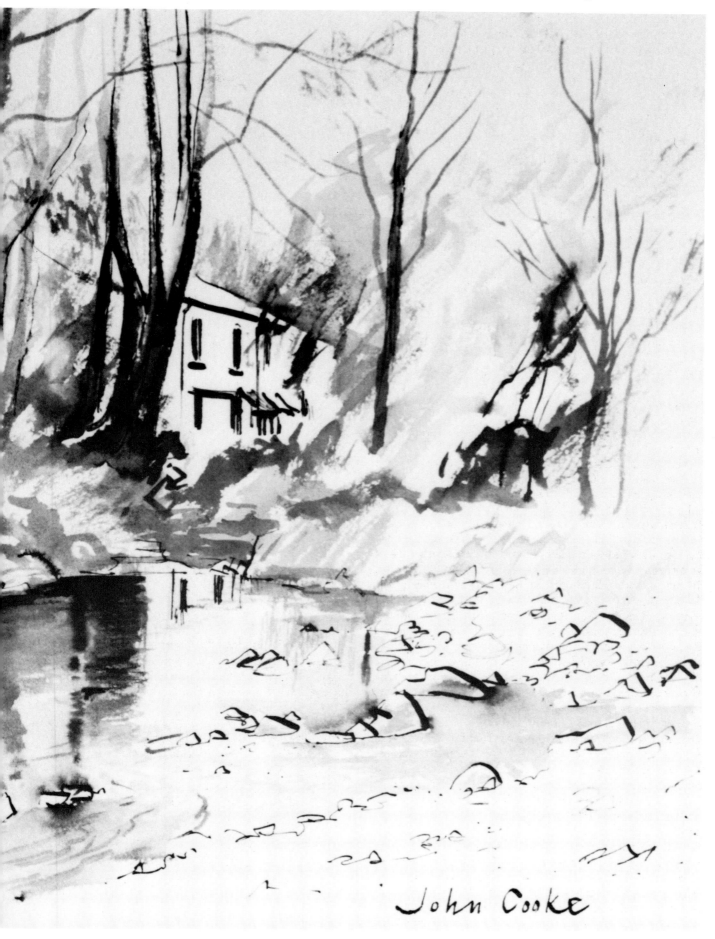

John Cooke

39 *Batsi, Island of Andros, Greece*. Pen and ink wash. $11\frac{1}{4} \times 16$in

is essential to modelling in light and shade and would also lessen the power of the dark shadows and reflections.

For outdoor drawing and sketching, a fountain pen saves the need for balancing a bottle of ink in precarious places and consequently having to buy many replacement bottles! A fountain pen nib is not very flexible but still gives a variable line. Rotring make a good art pen with a usefully long handle. I used one in Greece for the drawing in Figure 39. I did not carry any ink with me, and all the shading came from brushing water into the wet pen line. The few lines indicating the sea diminish in size to a sunlit headland, and this distance is enhanced by dark foreground tones.

Brush drawing alone may not have the emphasis of the pen line, but can nonetheless be just as clear and precise. *Cygnets* (*Figure 40*) and *Venice* (*Figure 41*) are two little drawings with a gentler feeling. They were drawn with greys mixed on the palette and so have slight variations of colour in them, although not enough to call them paintings, but adding a little extra interest. Different pressures used on a sable brush produce the same variations in thickness of line as a pen, ideal for drawing in the dark tones on a rippled surface.

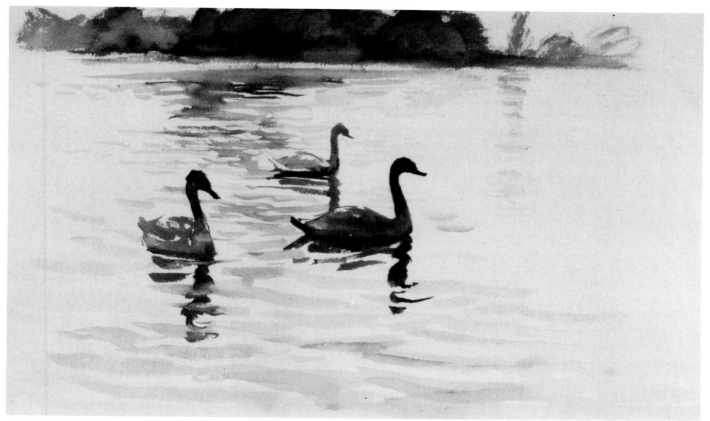

40 *Cygnets*. Brush drawing. $10\frac{1}{2} \times 14\frac{1}{2}$in

41 *Venice*. Brush drawing. 12×16in

42 *Little Pool*. Pencil. $10\frac{3}{4} \times 14\frac{3}{4}$in

Pencil drawing is an art in itself, offering perhaps more monochrome effects than any other medium. Fine and broad lines, hatching, smudging, rubbing out and shading over indentations can all be used to good effect when drawing water. *The Little Pool (Figure 42)* uses a number of these. I indented lines with an empty ball pen or brush handle, drawing in grass blades on the empty paper. When I shaded over, these became as visible as white lines. I continued the rest of the drawing in the usual way, making lines broader and using the worn down point for shading. Periodically I resharpened the point to restore a fine line. I indicated the water with firm lines mirroring grass and reeds, heavily shaded the dark bank and stones and gradually toned the surface from light to dark as it extended forwards. I used a propelling pencil with a soft but fine lead in Figure 43, *The Flooded Road*. As this pencil lacked the covering power of a broader lead the shading is mostly hatching, with the vertical lines in the pool differentiating between reflections and the free shading of the trees and house.

A simpler treatment of water is seen in *Girl with Skiff (Figure 44)*. As a background to the figure, a series of horizontal and vertical lines are sufficient to denote surface reflection.

43 *Flooded Road*. Pencil. $8\frac{1}{4} \times 11\frac{1}{2}$in

44 *Girl with Skiff*. Pencil. $8\frac{1}{4} \times 11\frac{1}{2}$in

45 *Flatford Mill, Suffolk*. Pencil and white gouache on grey paper. $11\frac{1}{4} \times 16$in

Pencil can be used in a versatile way, with white body colour on a mid-tone paper. This is similar to gouache painting in that you work outwards from a middle tone towards light (with the paint) and dark (with the pencil). *Flatford Mill (Figure 45)* shows this technique as most of the pencil drawing was done before the white was applied. It is quite exciting as you use the brush to see light flooding the picture. Remember again, the thinned down paint will produce a darker tone as on the brick work of the walls.

The River Wharfe (Figure 46) is drawn onto the rough side of Mi-Teintes paper, and you can see it has a grainy texture approaching that of charcoal. The difference between calm water before the weir and turbulent water below it is indicated by the reflected light. The smooth mirror captures the tree reflections in vertical lines drawn with horizontal strokes following the water surface. The broken surface presents many facets pointing in various directions and captures light from the sky in lines of white gouache following the ripples. I usually sketch with a 2B pencil which I find sufficient for most purposes although many draughtsmen have different preferences which fall among a full range of hard and soft leads.

The soft velvety smudging of charcoal is seen in *Evening, York (Figure 47)*. A finger drawn across the dark reflection a few times gives the water surface, and a rubber drawn vertically down beneath lights gives their reflections. Smudging the surface with your finger tones down the sky and softens the dark path and bank.

Whichever medium you work in, you will find water a stimulating subject, allowing you to exploit different techniques and effects. Most important of all, however, is to continue drawing in pencil or pen as this is the basic discipline of all visual art and essential to painting in any medium. Even when using colour, you must draw to express shape and form, using the dividing line between colour areas and to model light and shade. Drawing from life, still life or nature trains the eye to select what is required for your work and develops the skill to transfer it to paper or canvas. If you persist with your drawing it will become second nature and allow your imagination freer range when tackling problems of colour, atmosphere and the character of your subject.

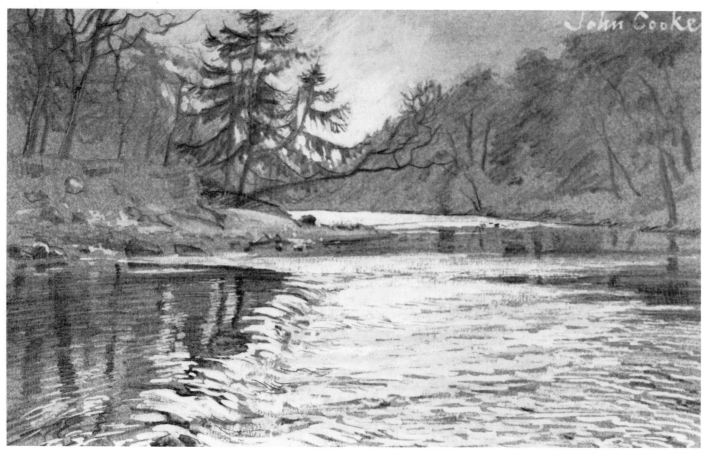

46 *River Wharfe, Yorkshire.* Pencil and white gouache on grey paper. $7\frac{7}{8} \times 11\frac{1}{4}$in

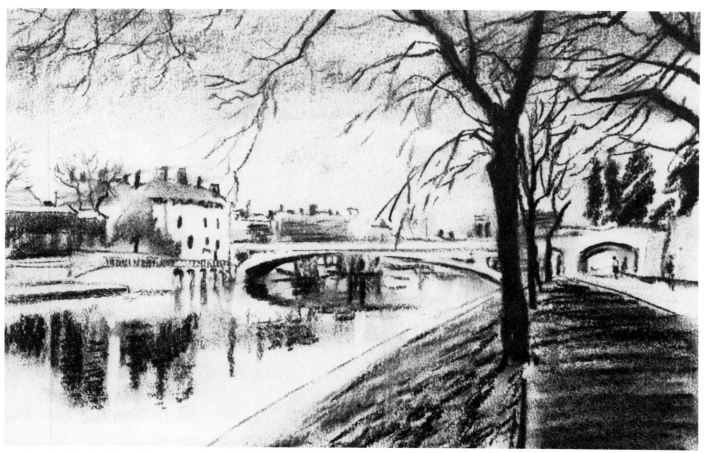

47 *Evening, York.* Charcoal. $11\frac{1}{4} \times 16$in

CHAPTER FOUR
The characteristics of water

Water is naturally variable. All landscapes alter their appearance with a change of lighting, season or weather, but water changes physically, with wind and high or low rainfall and according to the surface it lies on. A calm pool, perfectly mirroring its surroundings can break into a choppy surface with thousands of distorted images. A gentle stream trickling around stones can be transformed by heavy rain into an awesome torrent.

Usually, calm weather means calm water, but it is a rare day when we can set out anticipating the challenge of painting clear reflections on burnished surfaces. Nearly always slight breezes streak the water, and these lines of light can be useful in describing the surface. Even on the calmest day, running water shows lines as it follows the current, or flows around obstacles and over an uneven bed. It all adds to the diversity of the subject, each stretch of water being as individual as a patch of cloudy sky.

These different characteristics can be assembled under the following headings: Calm, Currents and rippling; Pouring and falls; Light and mood; and Shadows, reflections and refractions. Let's take them one at a time.

Calm

Wastwater is a dramatic spot. The screes sweep down to the lake accentuating its level plane, and on the day I painted it (*Figure 48*) the surface gave an almost perfect reflection. The mountain cuts out sky lighting, and the only light is where the usual breeze breaks up the surface. This effect is created by a couple of foreshortened strips scumbled on with a dry brush. I painted the rest of the water in vertical strokes, even where the sloping screes are evident. This vertical texture is important for suggesting reflections *into* the surface rather than lying on it. The reflections are very slightly hazier than the features themselves and either using a dry brush or painting on a slightly damp surface will produce this. The reflected stones and tree trunks help to give an effect of calm. Just under the screes, water rippled by the wind fails to catch the light but cannot mirror the slope either and so appears darker.

The rare occurrence of a perfect mirror image is seen in *Lancaster* (*Figure 49*). Because eye level is about 30 ft

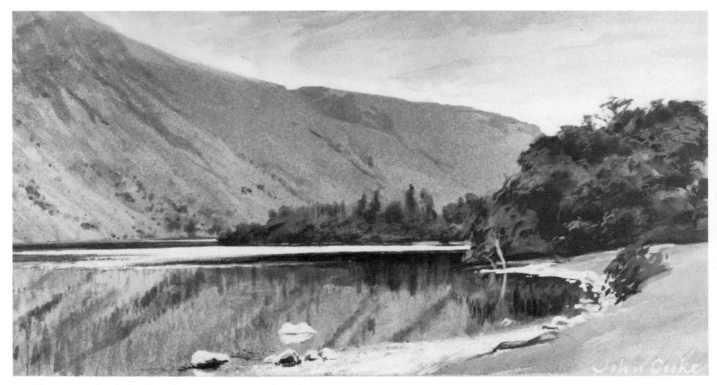

48 *Wastwater, Cumbria*. Gouache on grey paper. $7\frac{7}{8} \times 16$in

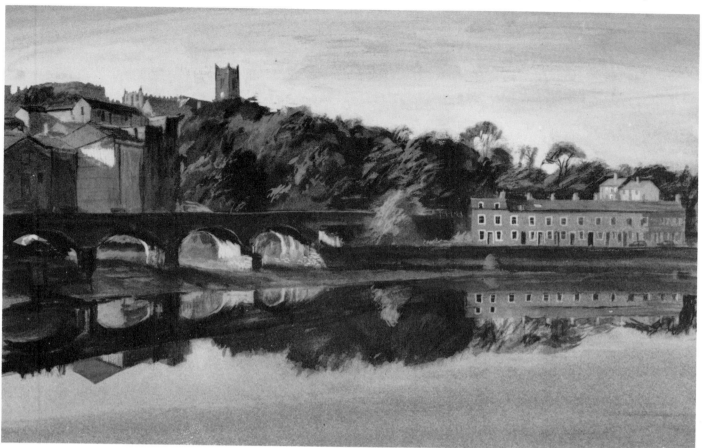

49 *Lancaster*. Stage 2

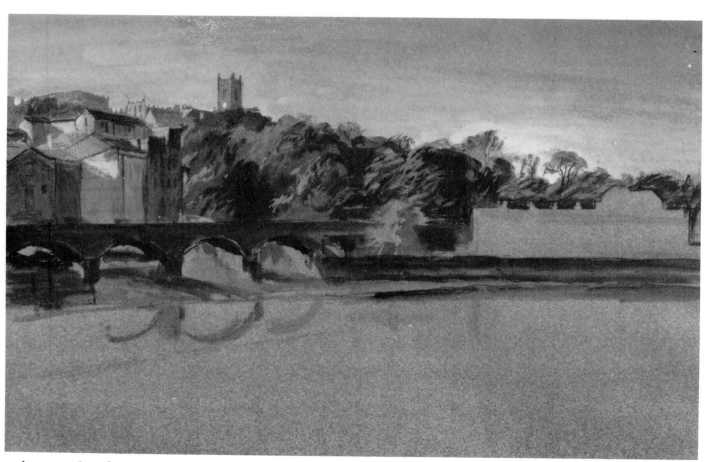

50 *Lancaster*. Gouache on grey paper. Stage 1. 14 × 20in

51 *Derwentwater, Cumbria.* Gouache on white paper. Approx. 10 × 16in

(9m) above the water the reflection shows more of the underside of the bridge and its top angles down through an effect of perspective. The water tone is slightly darker than the sky and I painted it in a careful wash of horizontal strokes before doing the reflections. Figure 50 shows how I worked on the top half before concentrating on the water.

Derwentwater (Figure 51) has slight rippling in the foreground which breaks up the reflected edge of catbells. These folds carry lines of light into the hill reflection, and I used a dry brush again to give a softer edge. This time the distant strip of light goes right up to the far shore and shows nicely below the dark trees. I first tinted the white paper, and the horizontal brush marks from this convey calm.

Currents and rippling

Once the surface of water starts to move it catches reflections from all angles and unless studied carefully can be difficult to analyse. A painting of Ullswater (*Figure 52*) shows quite clearly two different movements of the water surface. The stream is at the mercy of its rocky bed and folds and twists irregularly, finding the line of least resistance until it reaches open water. Out on the lake the stiff onshore breeze is blowing regular lines

of waves towards us. They curve slightly owing to the line of the shore, but there is also a pronounced angling away to the right which is due to perspective. The lines gradually merge in the distance into a continuous sheet of light.

Both lake and stream are really quite simply painted, the light being drawn on in white gouache on grey paper with a small brush so that one side of each ripple or wave is paint and the other side, not catching the light, is paper colour. The effect of running stream and windblown lake comes from understanding what is happening to the water, rather than from any complex painting technique.

52 *Ullswater, Cumbria*. Gouache on grey paper. 19 × 14in

The characteristics of water

Ripples from a central disturbance spread out in circles. We all know this from our stone-throwing schooldays. When you paint this effect it is important to realize that the nearer semi-circle will reflect light from a different face than the far one. This means that as a brush stroke of light circles round to point away from us, it fades out, and a new line starts between ripples. We can see this in Figure 53. A slight complication arises from the fact that the source of disturbance has decided to move away from us and so the circles are no longer concentric. In drawing an ellipse (which is what these foreshortened circles are) remember that the further half will suffer more foreshortening because it is further away.

The transition from calm to flowing is seen in Figure 54. A pool of water is held back by a natural weir of stones and so here reflections are relatively clear. Once over the weir the water moves more swiftly, the bed allowing some parts to flow faster than others. As a result the ripples fan out, and where the tree reflections continue down, some dark paint adds to the shaded side, without giving a clear image.

53 *The Blue Pool, near Sedbergh, Cumbria.* Gouache on grey paper. $11\frac{1}{4} \times 16$in

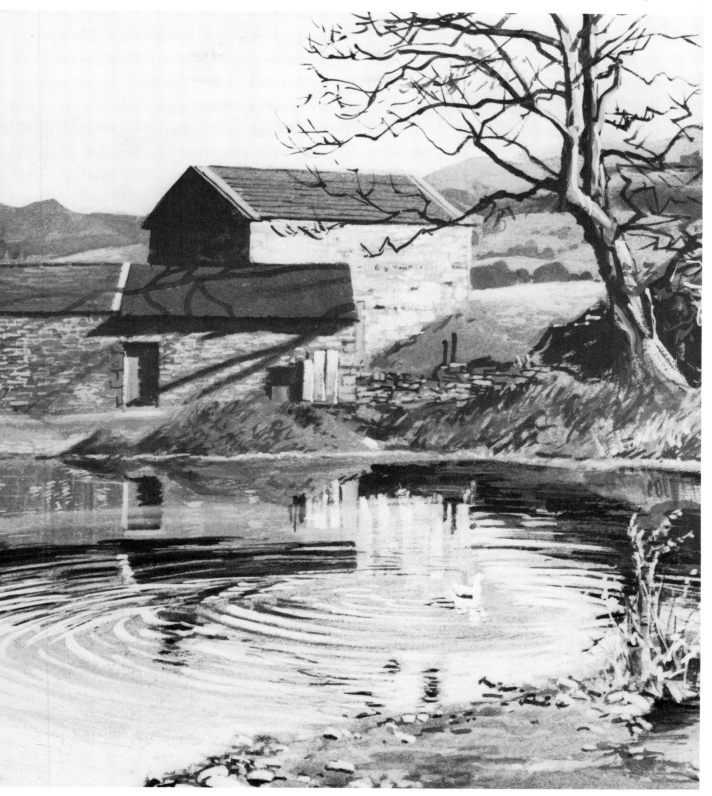

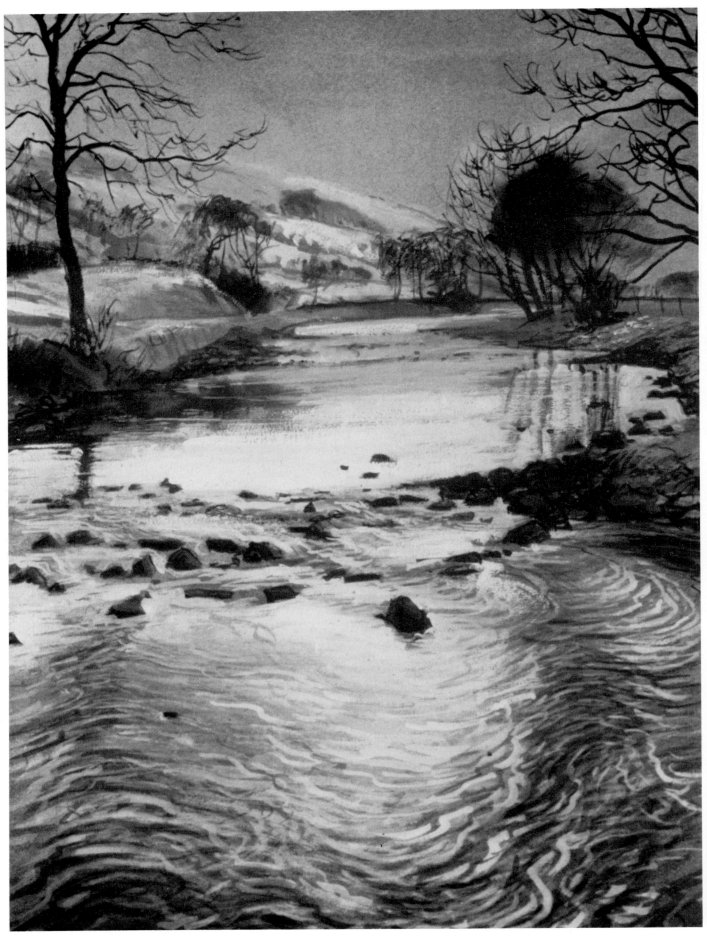

54 *Above Church Bridge, Dentdale.* Gouache on grey paper. 16 × 11¼in

Pouring and falls

A ball thrown into the air traces a graceful parabola as gravity affects it. The same forces apply to falling water, the energy of the thrower being substituted by the speed of flow. The view of Rash Weir (*Figure 55*) seen from the side is at the best angle for seeing this. The water brims over the lip of the weir, pouring through dips in the edge and distorting the reflections of trees as it does so. On the way down it strikes protruding rocks, which direct it into secondary courses before it foams away at the lower level. As with the pond ripples, I painted light on one side so that it did not completely follow the whole course, but thinned out, to be picked up again by another line. The whole effect is one of graceful movement contrasting with the calm of the upper part.

Another fall, which I painted head-on (*Figure 56*), loses some of the curve, but you can see the same splitting up of the lines as water strikes the diagonal shelf below the lip. A dip in this channels the water towards the centre, giving an opposite curve to the outer edge. This channelling is seen in another head-on view (*Figure 57*) of a narrow stream of water pouring over a stone. The water runs together and in doing so spirals slightly, just as bath water does down the plughole (anti-clockwise in the northern hemisphere, clockwise in the southern,

owing to the earth's rotation.) Some of the water is caught by the rock and runs down the face where it gleams darkly.

As I have said before, subjects occur in the most unlikely places. One day I saw a leaky gutter at the end of a barn roof sending out a thin stream, which was carried away from the vertical by a breeze. I immediately saw this as a painting, and Figure 58 is the result. It is a pen and wash with wax resist, but the thin stream is white body colour applied with a very fine brush. The snow patches and the light on road, walls and river are due to the wax.

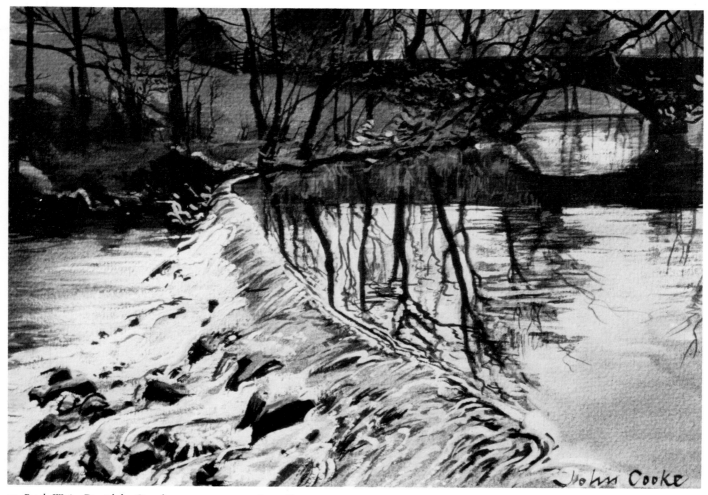

55 *Rash Weir, Dentdale*. Gouche on grey paper. $7\frac{7}{8} \times 11\frac{1}{4}$in

59

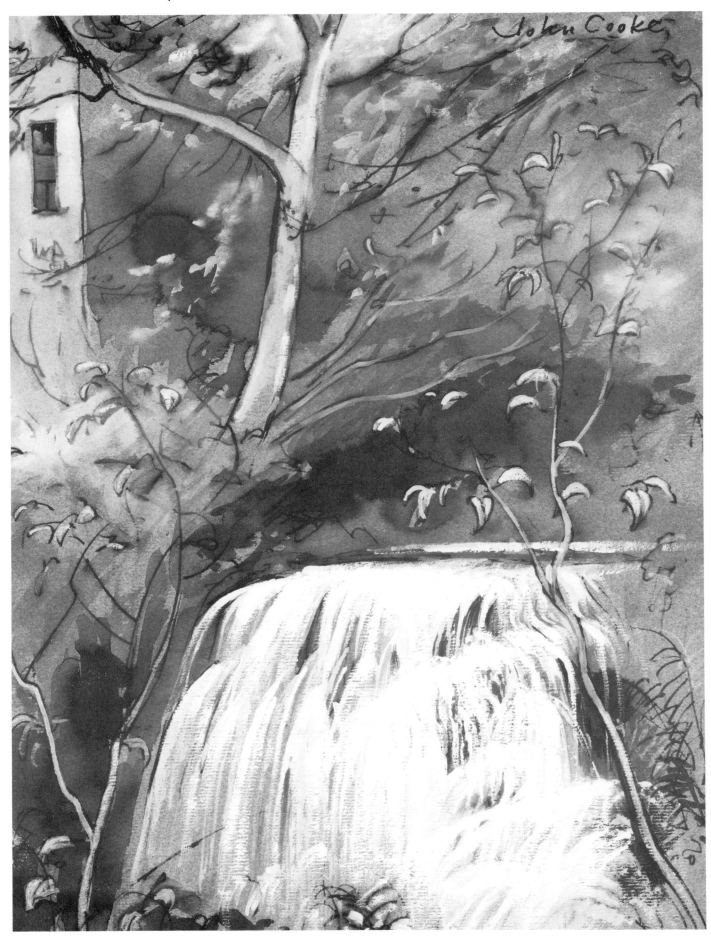

56 *Backstone Gill*. Pen and white gouache on grey paper. $11\frac{1}{4} \times 7\frac{7}{8}$in

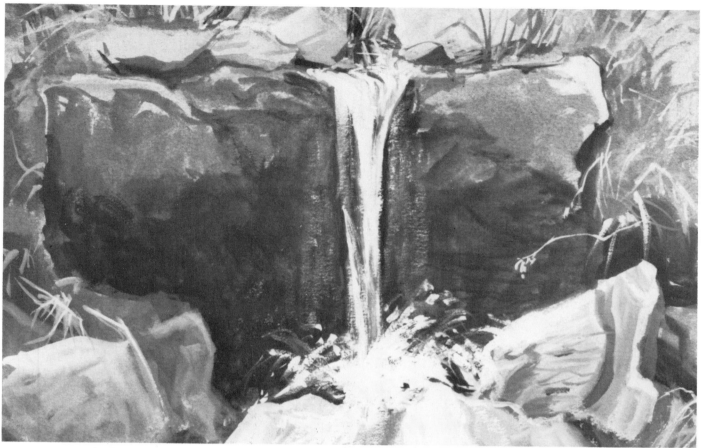

57 *Pouring Water*. Gouache on grey paper. $7\frac{7}{8} \times 11\frac{1}{4}$in

58 *Thaw, Ewegales Bridge, Dentdale*. Pen, gouache and wax. 14×20in

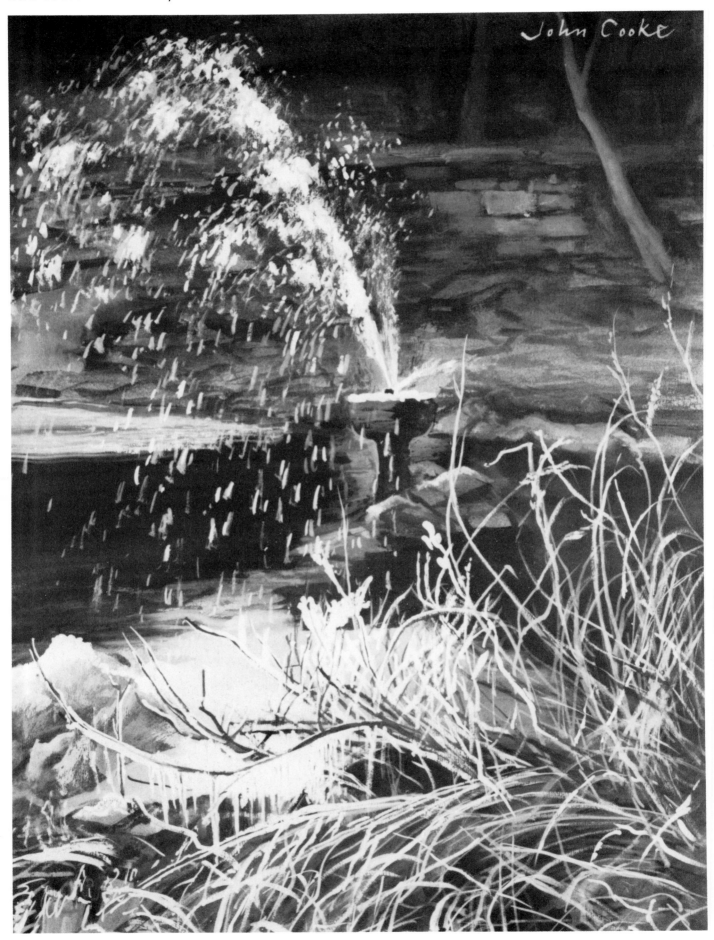

59 *Freezing Fountain*. Gouache on grey paper. $19\frac{1}{2} \times 14$in

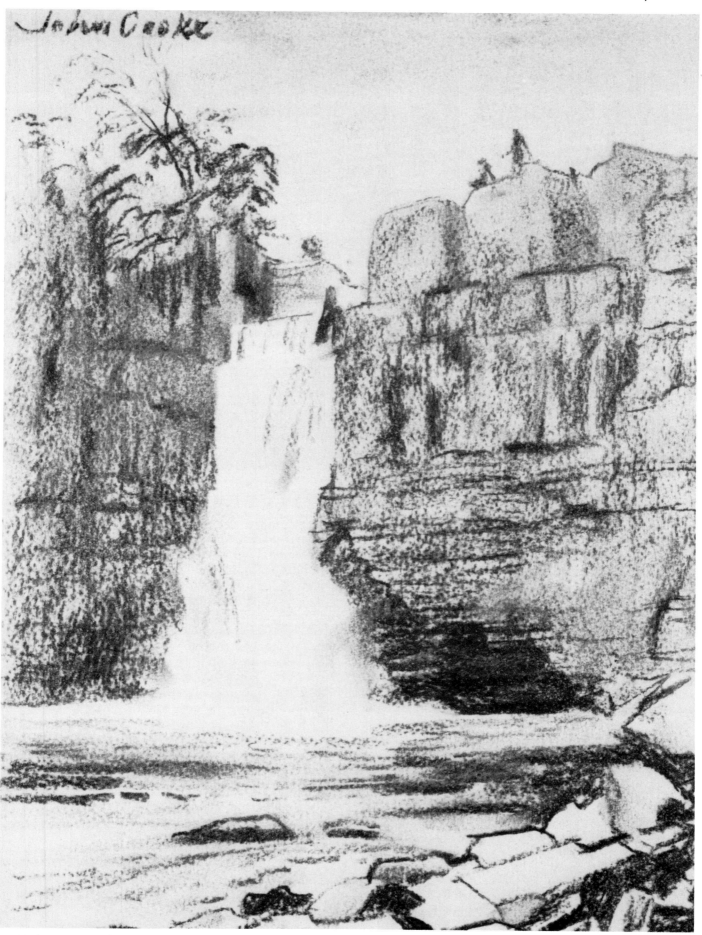

60 *High Force, Teesdale.* Charcoal. 16 × 11¼in

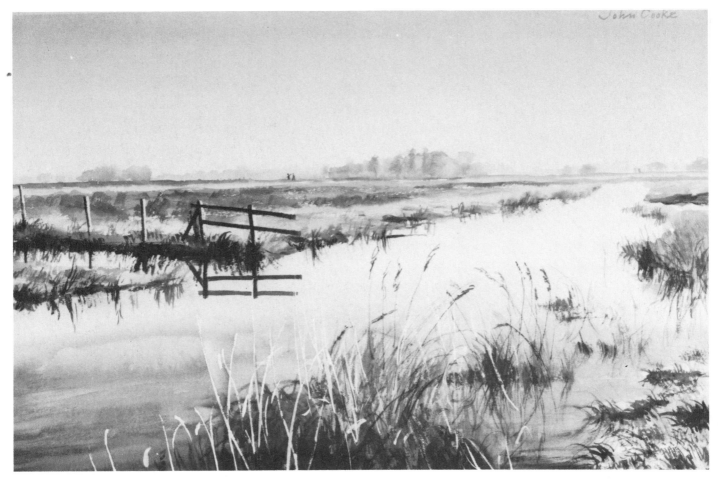

61 *Shipmeadow Marshes, Suffolk*. Gouache and resist. 14 × 20in

Fountains are made by water under pressure, and the curve begins with an upward movement. In *Freezing Fountain (Figure 59)* the water is carried towards us by the wind and as it breaks up into droplets, these appear to enlarge. I have streaked them out a little to suggest movement. They fall onto the nearby stems, encasing them in a translucent coating of ice.

Larger falls are powerful and awe-inspiring. I drew *High Force (Figure 60)* in charcoal, doing very little to the water, other than putting in a few lines and smudges showing a change in direction. The white paper was sufficient to suggest a thundering mass, with charcoal used edge-on and lightly smudged to tone the rest down.

Light and mood

The mood of a waterscape depends on light and surroundings. *Shipmeadow Marshes (Figure 61)* has a languid feeling enhanced by the level landscape and direct sunlight. The water darkens towards us, increasing its apparent luminosity, as it reflects a darker sky overhead but not visible in the picture. Two tiny figures and hazy trees speak of wide spaces, and the water is unruffled by any breeze. I painted the sunlit reeds and fencing with art masking fluid and, when I had rubbed it off, tinted the white lines with very pale Raw Sienna. This scene is close to the bottom of my old garden in East Anglia, and so a touch of nostalgia is present.

Although *Rash Mill (Figure 62)* is a tranquil scene, it has a vitality that comes from a sharper light in the water, concentrated in lines of ripples. The little fall, trees and overhead branches add a dynamic quality, whereas in *Shipmeadow Marshes* the reeds have the opposite effect of stillness. The fact that *Rash Mill* has no long horizontals, but plenty of vigorous brush strokes, maintains this liveliness.

62 *Rash Mill, Dentdale.* Gouache on grey paper. 16 × 11½in

Shadows, reflections and refraction

The complexity of water presents a variety of visual stimuli. If it is muddy and opaque, a cast shadow will lie on its surface, but if transparent and shallow, the shadow will lie on the bottom. Reflections will mirror in the surface as a whole, if calm, or with myriad facets if disturbed. Objects seen through the water look compressed, because water bends light rays, or 'refracts' them.

It would be very rare to see all these at once, but the little pen and wash drawing of a boat in clear Greek waters (*Figure 63*) shows reflection and shadow together. The shadow is on the sea bed and the reflection is beneath the boat, being darker and clearer where it appears against the shadow.

The way in which slightly rippled water distorts an image is shown in *Orford Quay* (*Figure 64*). The post has a wavy, elongated reflection, which I drew in direct strokes with a No. 8 sable brush, with a few broad fainter lines depicting the shaded side of gentle waves. Remember that this reflection is continually moving as you watch it, and you must try to capture its changeability.

One rarely sees a perfect mirror image. The nearest I have got to this is the surface in the tarn at Harry Guard's Wood (*Figure 65*). I used dry brush marks to create a slightly out of focus look, with occasional horizontal

63 *Boat at Batsi, Andros, Greece*. Pen and wash. $11\frac{1}{4} \times 16$in

64 *Orford Quay, Suffolk*. Gouache on white paper. 14×20in

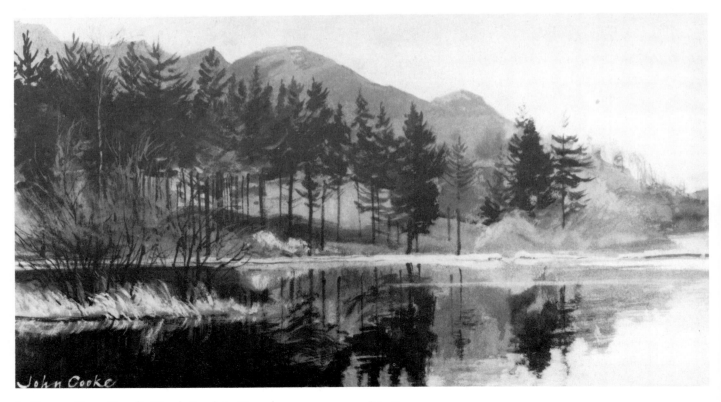

65 *Tarn at Harry Guard's Wood, Cumbria*. Gouache on grey paper. $7\frac{7}{8} \times 16$in

lines plotting out the surface. It is essential to paint the reflection as seen and not simply to repeat the landcape in reverse, as they rarely match up exactly.

The Pre-Raphaelites tended to paint their water nymphs ignoring refraction completely, thus avoiding compression and allowing graceful figures. This idealized version is used in the pencil sketch in Figure 66. Figure 67 shows what really happens.

66 *Naiad.* Pencil. $11\frac{1}{4} \times 7\frac{7}{8}$in

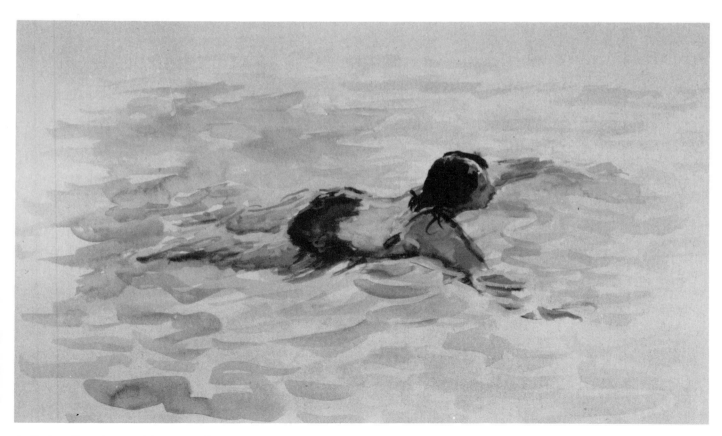

67 *Bather.* Gouache on white paper. $7\frac{7}{8} \times 11\frac{1}{4}$in

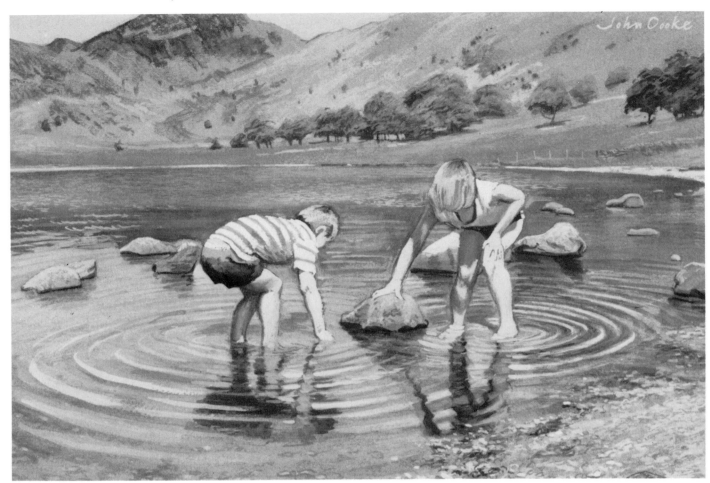

68 *High Summer, Blea Tarn, Cumbria.* Gouache on grey paper. $11\frac{1}{4} \times 16$in

High Summer, Blea Tarn (Figure 68) shows shadows, distorted reflection and refraction of the children's feet; the *Bridge at Ellers (Figure 69)* shows the bridge reflection and its shadow on the river bed. This may sound complicated, but it need not deter you if you recognize what is happening and paint each effect as you see it. As I said before, they rarely come together, but an understanding of them is half the battle when you set out to draw or paint.

When you think of the diverse nature of water it is not difficult to see that here we have a subject of endless charm and interest, always ready to surprise us with some unexpected display of pattern and colour, offering a challenge to the painter. I have tried to suggest ways of taking up this challenge by explaining the way I tackle the problems, but always be ready to grasp new ideas as they come to you and explore different ways of expressing them.

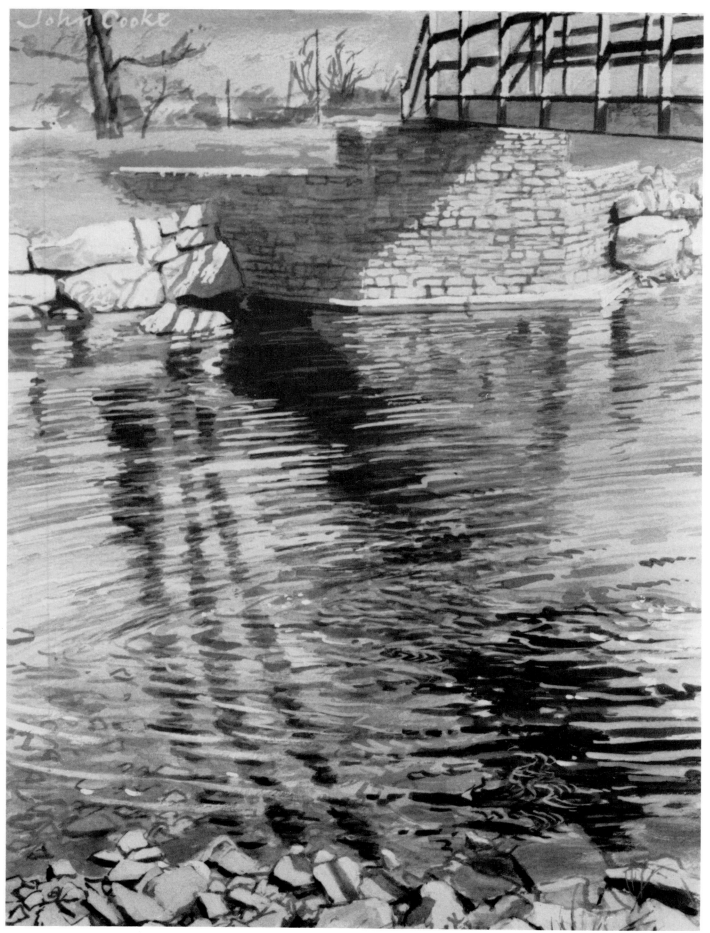

69 *Bridge at Ellers, Dentdale.* Gouache on white paper. 16 × 11¼in

CHAPTER FIVE
Weather and seasons

Landscapes change from hour to hour, day to day, season to season, but no feature changes so much as water. Water not only reflects the mood of its surroundings but also distorts them with its agitated surface or angrily blots them out altogether. Because of the transient nature of these moods capturing the moment of painting is very important.

Compare the painting in Figure 70 with Figure 71 which is done from almost the same spot. In Figure 70 fresh greens show through the overhanging trees that darken the river with their reflections, except where a patch of warm sunlight shines through in the centre. The dark shadows effectively contrast with the sunlit leaves, and the foreground is lit by a warm sun. What a contrast

this is to *Winter River*, with its low sun gleaming through bare branches onto water and snow. This starkness typifies the winter scene; spring and autumn show the transition between this effect and that of enclosing foliage cutting out the light.

In early summer I usually make a pilgrimage to the Lake District, and one of my favourite spots is Loughrigg Tarn. Not far from Ambleside, it is hidden from the road, and you must follow a footpath for a little distance before it comes into view. Those who find it are rewarded by an idyllic scene.

My painting of it in Figure 72 has a high eye level cutting out the sky completely. Its reflected blue (Prussian) and the warm browns and yellows (Umber, Sienna

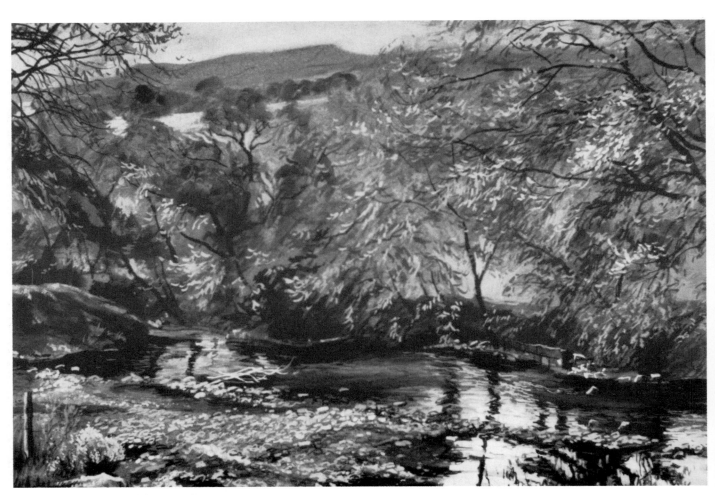

70 *Summer River, Dentdale*. Gouache on grey paper. 14 × 20in

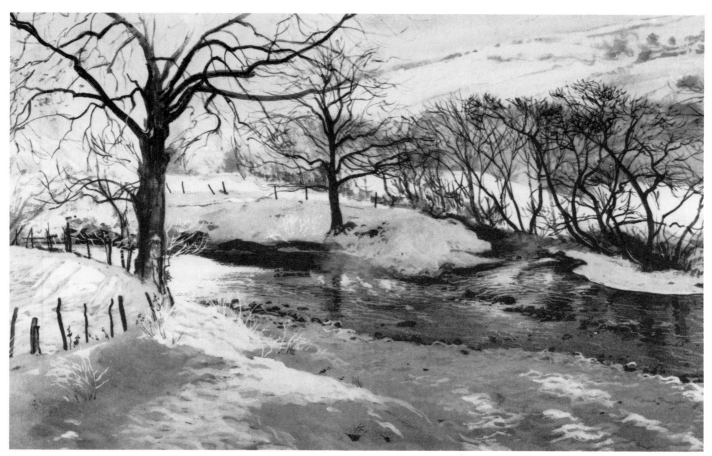

71 *Winter River, Dentdale.* Gouache on grey paper. 14 × 20in

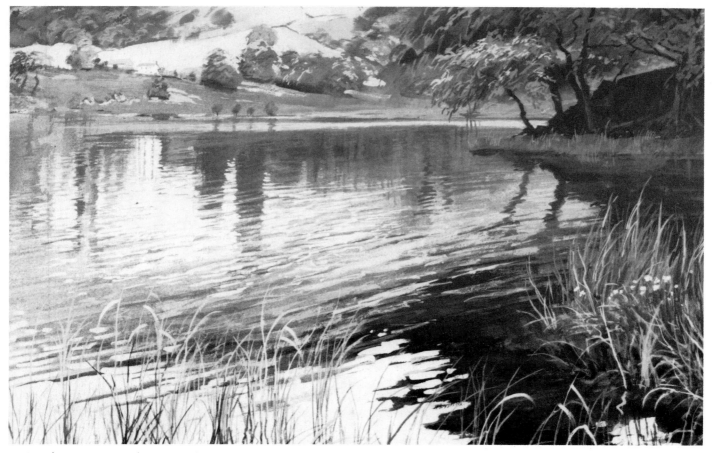

72 *Loughrigg Tarn, Cumbria.* Gouache on grey paper. 11¼ × 16in

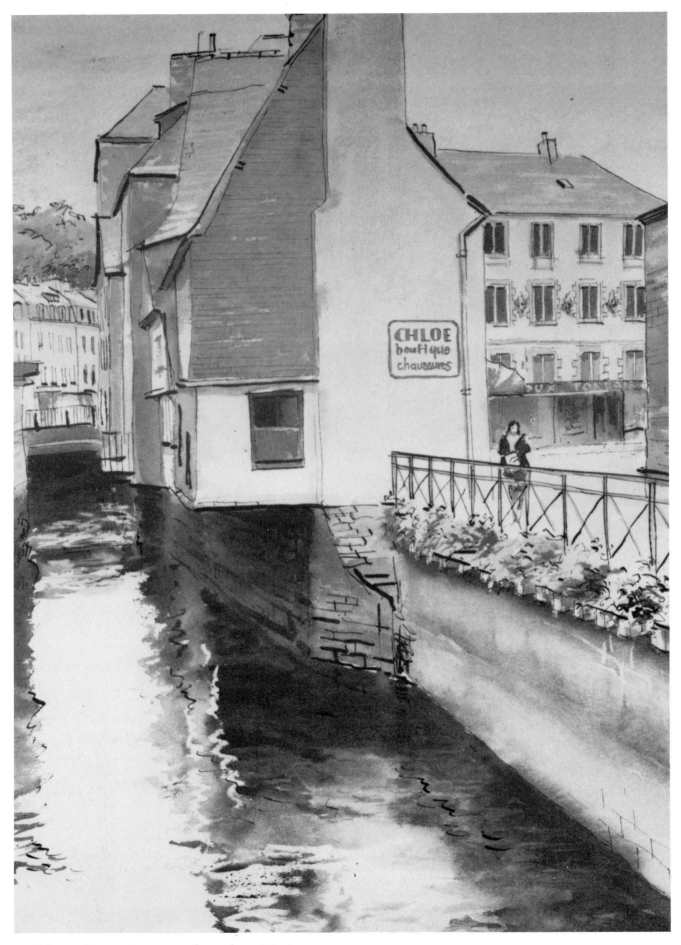

73 *Quimper, Brittany*. Pen, wax and gouache. 19½ × 14in

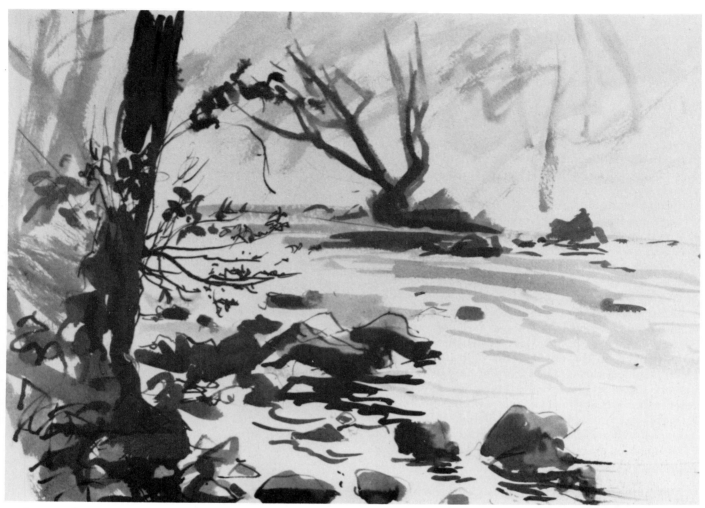

74 *River Study*. Pen and wash. $11\frac{1}{4} \times 16$in

and Crimson) of last year's bracken give the painting a languid summery feeling and dark reflections are used to show up a clump of yellow flowers. I carefully changed the tone of the reeds as they came up to the dark reflection, giving a counter change which I often use for this type of subject. A fine No. 2 Daylon brush is ideal for painting these and it spreads just enough to show the broadening at the top. For the larger areas I used a No. 8 sable and I find that these two brushes are sufficient to work on any painting of average size.

In a town there may not be many direct indications of the season. Short shadows, warm sunlight and summer clothing are indirect clues, but often some little feature will make a definite statement. A border of flowers by railings and distant full leaved trees over the roof tops place *Quimper (Figure 73)* in the summer season. It is a delightful town with lots of quaint buildings. It has a large river, but this little tributary stream took my fancy. I painted it at home from a photograph, using pen, wax resist and washes of gouache. Crimson, Raw Sienna and Burnt Umber produced the sunlit walls, Prussian Blue and Sienna the greens, and Indigo and Umber the deep shadows and reflections on the water. I used Indigo and Crimson on the slate roofs and wall cladding, which has wax lines, suggesting the slates, drawn at intervals during the painting. The wax is evident in the water and the texture of the walls and sky. I used a pale pink, made of

white and crimson, to paint the flowers and young girl's blouse.

Summer trees darken the water with their reflections. Colour plate 6 is a detail of a painting of mine of the River Rawthey, near Ambleside. I chose this because it shows how dark water can be used to show off foreground features, and was particularly useful for highlighting the beautiful summer flowers. I used gouache on white paper, which I toned down with a variety of greens before overpainting it with lighter colours. The water and background are loosely suggested so that attention is focused on the plants. Reflection and surface marks are light on the dark water and dark in the light foreground.

Most of my subjects come from walking or cycling around the local countryside. One morning I was wandering by the river with sketch book and camera. I was particularly interested in the way the leafy trees filtered the sunlight, catching the water in places and showing up trees and stones in dark silhouettes. One of my sketches is shown in Figure 74 where I used pen and wash to try to capture these effects.

Weather and seasons

However, I eventually painted *Green and Silver River* (*Figure 75*) from a photograph, remembering, of course, what I had learned from the sketches. Using white paper again, I tinted the whole with greens as in the previous painting and used neat white gouache to paint the sun and its effect on the water. I used a little crimson sometimes with the greens, and when the white paint was brushed on, quite wet, it picked up some of the background colour, producing a silvery effect. I put some black on the dark trunks as well as my usual Indigo and Burnt Umber, and this really set off the light. The rays filtering through the trees were washed out with brush and clean water and then dried with the same brush wrung out between thumb and finger. I overpainted the nearby leaves on this in dark greens, and used light greens to edge the tree on the far bank where it catches the sun. The colour scheme goes from black, through various greens and a silvery grey to neat white, the green being Mistletoe.

Green is, notably, a difficult colour to use without creating a rather acid look. I sometimes use Viridian or Fir Green along with, or instead of, Mistletoe, but very often I make up the greens with yellows like Sienna, Ochre, Golden (this is called Chrome Yellow in oils), or Lemon. Prussian Blue gives a lovely green with these colours and a beautiful dark one with Burnt Umber or Burnt Sienna; a touch of Crimson will tone all of these colours down well. A smudge of bright green among more subdued hues will suggest a verdant landscape without being acidic in tone.

75 *Green and Silver River, Dentdale*. Gouache on white paper. 14 ×

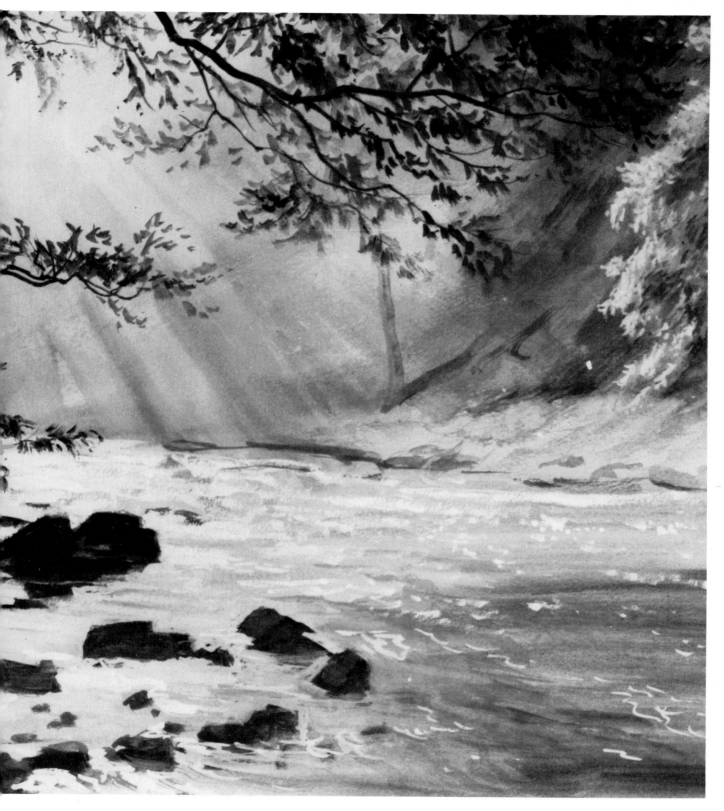

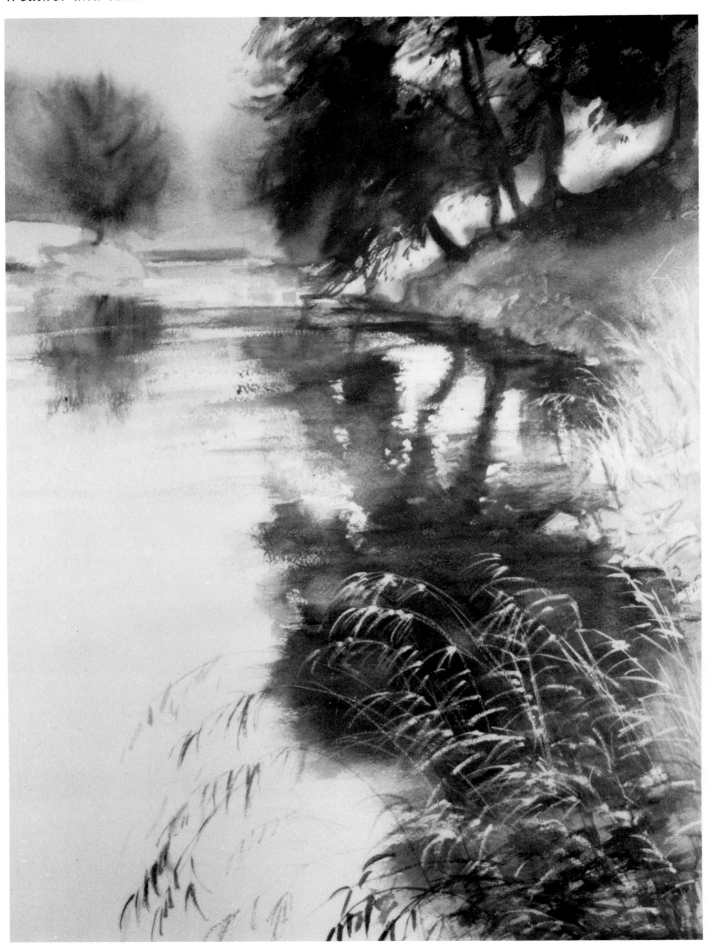

76 *Misty River, Dentdale.* Gouache and wax. 19½ × 14in

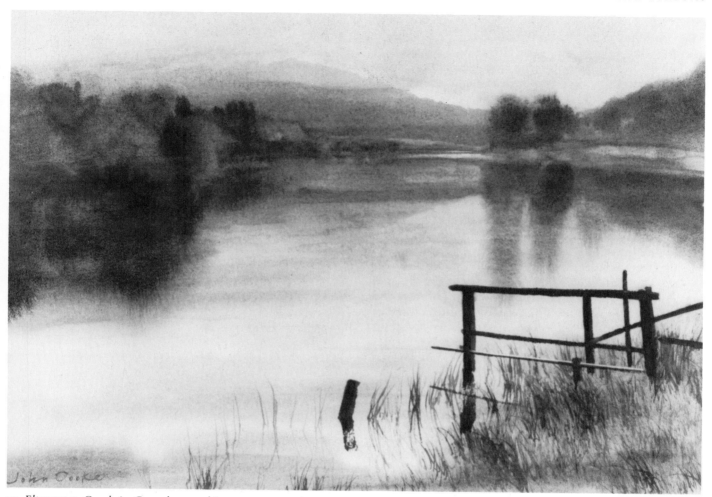

77 *Elterwater, Cumbria.* Gouache on white paper. 14 × 20in

Summer is not all greens, particularly later on when the first mists arrive and the grass has been parched by earlier dry spells. Painted upstream of *Green and Silver River, Misty River (Figure 76)* is predominantly blue and brown. I painted the distant trees wet on wet with Periwinkle, running the paint to give it a nice, hazy outline. Before changing to Indigo for the nearer trees, I drew with candle wax to retain light among the leaves and to describe the water surface where it reflected light. The dark washes of Indigo and brown brought the trees to life, with a little Sienna in lighter washes on the river banks.

The grasses were painted in with a No. 2 Daylon using white and Sienna, to highlight them against dark reflections. I changed colour to a dark brown mixture where they arched forward against the light. These graceful lines of grass stalks, heavy with seeds and moisture, are an important feature, and it would have been very difficult to portray their delicacy with a resist.

Summer gradually gives way to autumn. Calm anti-cyclonic days produce crisp blue skies or layers of mist held down by temperature inversions. The painting of *Elterwater (Figure 77)* shows an overflowing mere with a crisply painted foreground receding into a misty distance. The haze is quite obviously achieved by painting wet on wet. The trick, however, is how much to wet and how far to allow it to spread. It is useful to have a clean brush and tissues to hand so that you can correct excessive spreading. A dry tissue dabbed below the two trees to the right ensures two separate reflections, while clean water brushed over the hilltop suggests a bank of mist. This painting is done with gouache, used completely like water colour except for the line of light on the fencing.

The landscape gradually opens up, allowing more light to fall on the water and previously hidden branches begin to appear. Walking upstream towards Church Bridge (*Colour plate 7*), I captured this light on film. Such photographs are not works of art in their own right; a certain amount of composing is done through the viewfinder, but the quality of tone, light and drawing comes through the painting which is seen in the mind's eye before the photograph is taken.

A strong breeze had thinned out the leaves so that the sky played a larger part in the composition. The river was not very high but it ran swiftly along its stoney bed. This

broke the surface into ripples which prevented clear reflections except in a calm patch under the bridge. In painting the light water seen through the bridge, I scumbled the paint on dryly, the resulting texture suggesting distant ripples. I painted the nearer water in wet greys to allow tones to run into each other, which then dried before I added the lines of flow. Dark banks and tree trunks allowed golden leaves (Raw Sienna and Golden Yellow) to show clearly. Nearly all the colour is in the top two thirds of this painting with grey paper and purple-greys of Indigo, Umber and Crimson on the bridge and stones, which are freely outlined in darker greys. Touches of light line their tops. A little golden reflection appears in the water. I toned the sky down somewhat to enhance the light on the water, which is pure white gouache.

This river is fed by streams running down gills (or ghylls). These are water courses which cut through the surface soil and expose bed rock in a series of falls and pools. *Flintergill (Figure 78)* shows a moderate amount of water running and fallen leaves littering the rocky steps. At first the background looks chaotic but on further study it proves to be less complex than it seems. I used white paper and tinted it all over with varying green-brown-greys to a medium tone. Then I lightly brushed in background trees and introduced the sky into the gaps with white gouache toned down with a little blue. (This white can be made to pick up a little of the background grey paint which helps to blend it in.)

Then I darkened background trunks and added branches. In the foreground I sketched in more branches with the brush, and added both light and dark leaves. Remember that you most decide when to establish a branch firmly with its light and shade and when to overpaint with leaves to get the intertwined appearance of dense scrub and woodland. I put in the rocky steps a little before doing this with the brush and then defined them more clearly with light tops and darker walls. Then I carefully drew in the water, which is the main feature of the painting, to follow the level tops and plunge over the vetical steps, finally meandering in gentle ripples over the large foreground rock and falling away at the bottom left. The loose rocks on the right are lightly drawn in with a brush, most of their colour being in the underpainted grey. A dark patch at bottom left suggests the gill continuing downwards.

The delight of these places for me is their secretive quality; each little fall has its own character and you can wander up and down collecting idea after idea, each in its own way unique. As a small boy I lived on the edge of Hanley Park in Stoke-on-Trent. It was an exciting place for a five year old and I was taken for walks to see the kingfisher in a small pond there. On a recent visit I found the pond still there, but it was backed by a modern square building that destroyed its seclusion. The building did, however, provide rows of lighted windows – a cheerful sight on that dark, late autumn afternoon. Despite my disappointment I felt nostalgic enough to paint the site. (*Figure 79*).

It had been snowing and a small wet patch lay in a hollow behind the reeds. The water was smooth and dark and I painted it with vertical brush strokes, blurring them

78 *Flintergill, Dentdale.* Gouache on white paper. 14 × 20in

slightly around the edge of the tree reflections. Bronze leaved trees, probably ornamental cherries, glowed warmly on the slope above, calling for a mixture of Raw Sienna and Bengal Rose. The windows had a colder look against these, and I forsook my Raw Sienna for Lemon. Interestingly, the reflections show the dark undersides of

the trees. I muted the whole painting to show up the lighted windows.

Autumn in the Lake District is a sight to behold, and another favourite spot of mine is the tarn in Colour plate 8. Harry Guard's Wood lies on the Ambleside – Coniston road, and its lovely tarn is conveniently by the roadside,

encouraging people to stop and enjoy its beauty. In this painting most of the leaves have gone, except on the larch trees covering the hillside, where a range of autumn colours reflect in the water. I used the same vertical strokes as in the previous painting for the water and strong lines to reflect tree trunks. The wind-ruffled

79 *Kingfisher Pool, Hanley Park, Stoke-on-Trent.* Gouache on grey paper. 11¼ × 16in

surface and the reflected sky were painted in horizontal strokes, very small ones in the middle distance, and I softened the edge of the sky reflection with a wet brush. A few evergreens contrasted with the larches, and I used Prussian Blue and Burnt Umber to get a dark rich green. A little purple of Cobalt and Crimson went into the shadows, and the reflected colours were kept to a lower tone than the hill itself. This enhanced the polished look and added a mysterious quality to the water.

Once again the foreground reeds change from light to dark. I used a very dry brush on some of the hillside which produces a pastel effect, especially on the grey (virtually pastel) paper. This blurred the far trees and, therefore, gave a greater clarity to the very dark near ones which spoke of approaching winter.

Snow comes early to Dentdale, and a powdering on the hilltops can be seen as early as November (a 'greying' as the locals say). But there can be quite long periods without snow, and *Deepdale Beck (Colour plate 9)* shows the starkness of winter without its covering. I was attracted to the low sun shining through the trees (compare this effect with the summer rays of *Figure 75*) and the dark masses on either side, which gave a good opportunity to introduce colour for its own sake.

I covered the white paper with a blue-grey, using Periwinkle (a vibrant blue) where the background hill was to be. I painted the sky over this in white, and its edge outlined the hill, leaving that first clear wash of Periwinkle showing. I allowed the blue to run into darker

Indigo and Umber, giving a hazy distance. I worked gradually through the shrubs and trees towards the foreground, sometimes working on wet paint, sometimes allowing it to dry, introducing rich mauves and purples of crimson with Indigo, Periwinkle and Cobalt, toned down here and there with Umber and Sienna. The same silhouetting appears as in the summer painting, but the colours and the stark trees proclaim the season. I scumbled the distant water with a dry brush and changed gradually to more defined strokes following the flow of the water, which held varying shades of the other colours beneath the white. The sun behind trees appeared to cut out trunks and branches with its dazzling light; I achieved this effect with thick gouache quickly drawing a dry brush across it to produce the rays.

When the snow does arrive it works a magical transformation. Light is everywhere, and under a mid-day sun the scene is dazzling. *Winter Sunshine (Figure 80)* shows how snow takes over from the water as the chief source of reflected light. Even so, the water has to remain luminous, and I used a little Alizarin Crimson with Indigo to give a graded tone, deepening towards the lower edge. The snow is pure white with Cobalt shadows but in the reflections it has a little Raw Sienna to maintain the contrasting warmth of the water. Two important features are the snow covered branches against dark shadow (Indigo and Umber) and the post and its reflection. Notice how the background tones are all kept lower than the foreground darks. This painting was used

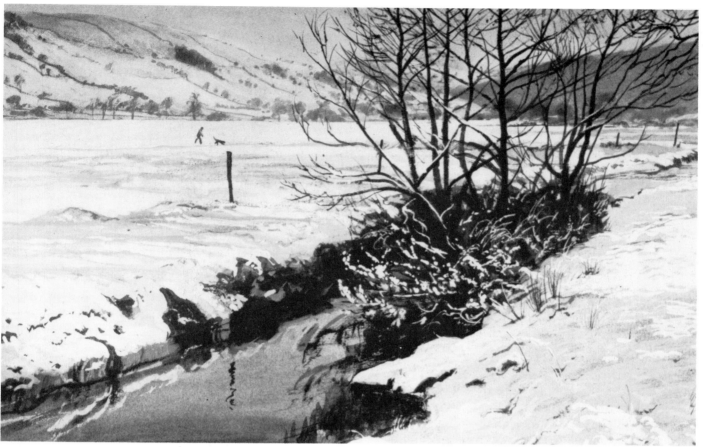

80 *Winter Sunshine, Dentdale*. Royle calendar. Gouache on grey paper. $11\frac{1}{4} \times 16$in

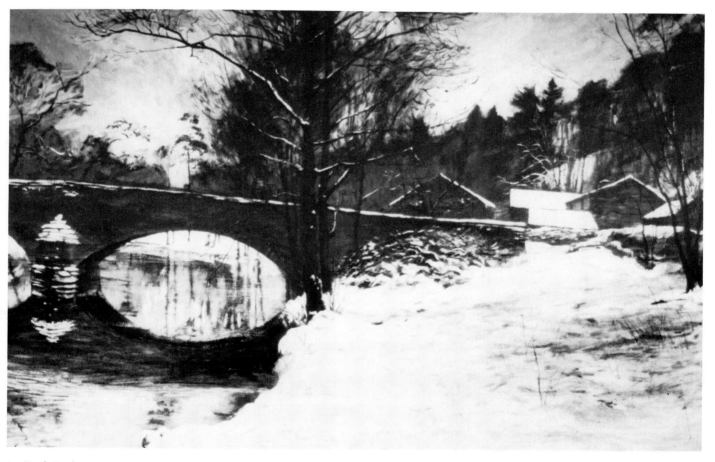

81 *Rash Bridge, Snow, Dentdale*. Acrylic on ply. 24×30in

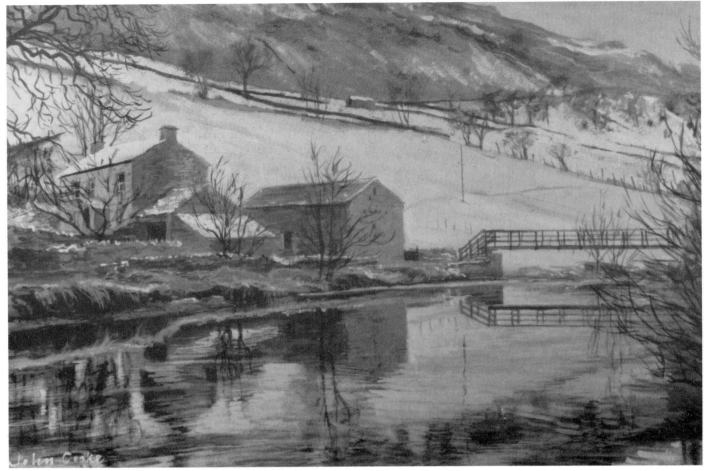

82 *Footbridge at Ellers, Dentdale.* Gouache on grey paper. $11\frac{1}{4} \times 16$in

by Royle in one of their Artists' Britain calendars to illustrate December.

Another snow painting on a sunless day is shown in *Rash Bridge (Figure 81)*. This is an acrylic painting on ply which was first primed with white emulsion and then darkened with grey washes of acrylic. Without the snow the water would undoubtedly be the brightest foreground feature. To achieve this, I lowered the sky tone more than usual to produce that marvellous 'photonegative' effect which snow creates. A touch of crimson mixed with the sky and water enhances the cold snowy light.

Footbridge at Ellers (Figure 82) is a much lighter painting, though still without direct sunlight. It shows how the buildings and bridge can be used to depict the water surface with their reflections, adding interesting shapes and textures. A slight current lines the water surface, breaking up the reflections as they approach in larger ripples.

Note that reflections are rarely perfect mirror images. Often they are somewhat elongated, like the chimney and pole, and they need to be studied carefully to be convincingly depicted. Tone down the reflected snow slightly by allowing grey paper to show through so that the hillside is the lightest part.

When water turns to ice, all its characteristics disappear as it becomes a completely different element. The *Frozen Tarn (Figure 83)* is easily recognizable as water in this state. It is level, it has an irregular outline and it catches the light to a certain extent. It simply does not mirror images or break into an uneven surface. Also material is held on the surface rather than floating in it. As the tarn moves away from us it reflects less light, and this darker area shows up snow patches blowing across the surface, and also has shadows cast on it from stones and banks. The white snow outlines it admirably, and the carefully drawn edge indicates its perspective. Jumbled rocks and ragged clouds above serve to emphasize this one level patch. An important feature is the snow-free slope, its darkness offsetting the white and mid-tones.

The thaw comes, often resulting in flooding. The waterlogged field in Figure 84 held water from the nearby river, which had overflowed. It is done in pen and wash with wax resist, the wax producing textured light at the far edge of the water. Nearer to, wax helps to suggest ruts and hollows holding water and, in the trees, helps to break up the skyline of twigs and branches. With crisp penlines I drew in the trees, their reflections, the wall top and fencing and a suggestion of grasses nearby. I applied a brush to the black ink line while wet to produce dark distant trees with the edges carefully softened with water.

We all look forward to the spring. In the Dales it can be a little late with storms and cold winds delaying the first appearance of fresh green, speckling trees and hedgerows. When it does arrive my palette changes from its winter colours to include Mistletoe and Viridian, and their appearance in the water enlivens it.

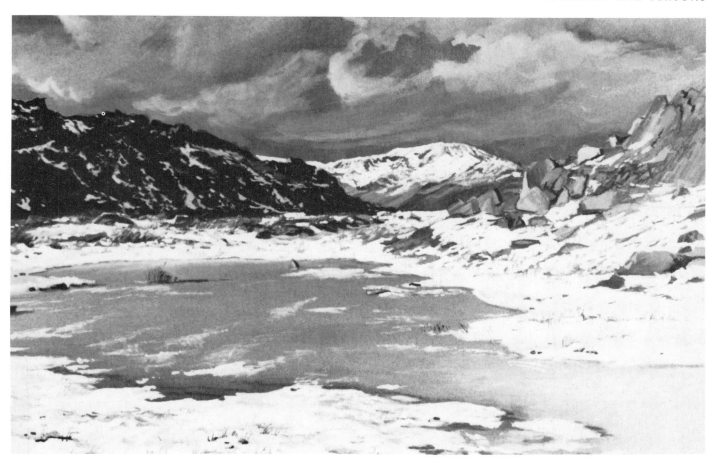

83 *Frozen Tarn, Cumbria*. Gouache on grey paper. $11\frac{1}{4} \times 16$in

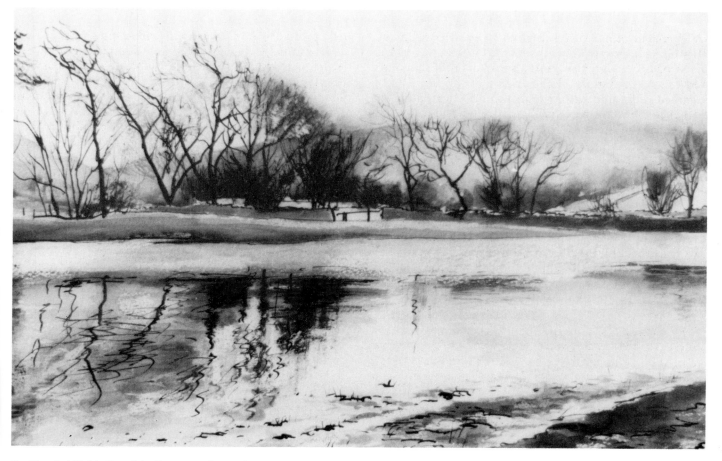

84 *Flooded Field, Dentdale*. Pen, gouache, and wax. $11\frac{1}{4} \times 16$in

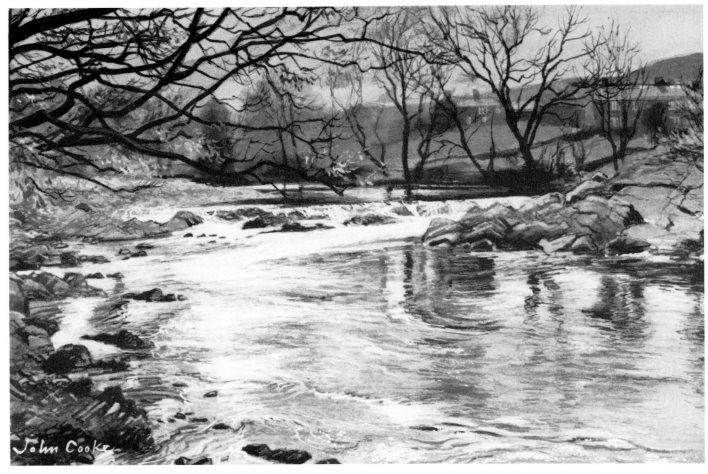

85 *River at Millthrop, Dentdale.* Stage 2. Gouache on grey paper. $11\frac{1}{4} \times 16$in

The *River at Millthrop* (*Figure 85*) is swiftly flowing after heavy rain, covering most of the large stones except at its edge. Trees are still wintry fingers, but the first buds add touches of light green heralding the spring. I have included a stage just before finishing off the water (*Figure 86*) to show how the carefully graded lights and darks add a sheen to the surface. You can see the brush drawing which sketched in the stones and reflections before the final covering of paint. The colours are still wintry greys, but Lemon Yellow and Mistletoe Green catch the eye among the branches.

The painting *River in Spring* (*Colour plate 10*) shows the water at a lower level, gathering in pools between the rocks and so reflecting clear images. This allowed me to use fresh greens in the trees and water and on the sloping field beyond the river. I made the hazy background of thin washes of Indigo with thicker individual brush strokes of white in the sky.

I painted the trees moving from the background getting tonally darker with each stage. I then painted leaves and branches, making the same decisions as in *Flintergill* (*Figure 78*) as I proceeded. I used Mistletoe Green and lightened it with some white on the field, adding Lemon and Sienna for the leaves. Because of the mistiness of the day, the overall effect was of a silver grey, and this came out in the water with a slight tinting of Indigo away from the brighter areas, together with grey paper showing through the thin washes. Touches of light Sienna on the stones added to the quiet light.

I was asked to do a canal painting for a Shell calendar of British waterways and I took a trip to Llangollen in

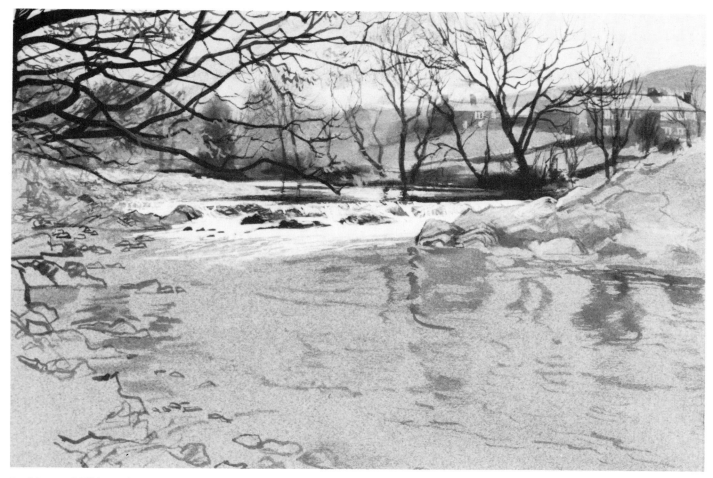

86 *River at Millthrop*. Stage 1

search of subjects. After various sketches and photographs I decided on this view (*Figure 87*) a mile or two out of the town, and used a wax-gouache technique on white paper. Most of the light colours are retained by the wax, noticeably in the wild garlic on the canal bank and in light through the trees. Some of the ripples from the barge were retained with Copydex (*see* Chapter 3 on various media). Some pink blossom on the distant tree and a haze of bluebells above the barge (sprayed on with a stiff brush) added variety to the yellow-green, with dark trunks and reflections making a strong pattern. The girl waved and smiled as the barge passed, adding to the pleasure of the scene.

Landscape features can be kept to a bare minimum in a waterscape. A few partly submerged branches take up

only a third of *Windermere Shore (Colour plate 11)*. The rest is rippling light and shade, offset by the upward curve of the branches and their new leaves. I used a white paper, tinted with various fresh greens mixed on the palette from Lemon Yellow, Raw Sienna, Prussian Blue and Indigo. The dark branches and reflections, done in Indigo, Umber, and Raw Sienna, were overpainted along with the light through the trees and on the water. It is a refreshing scene typifying the season, and I was pleased to feel that a simple subject could produce a satisfying picture.

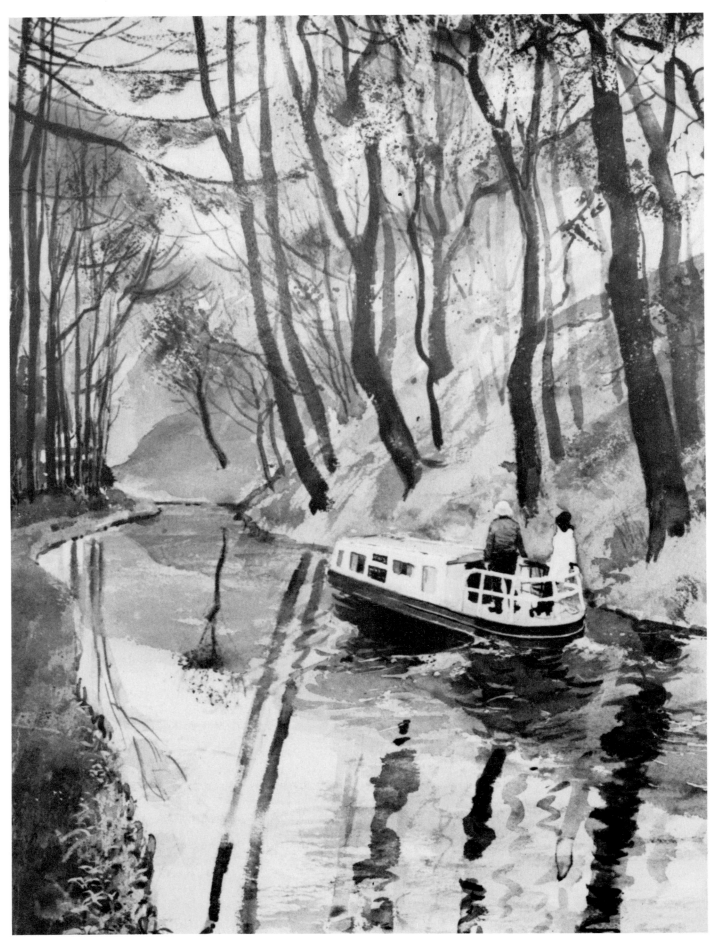

87 *Llangollen Canal, North Wales.* Shell calendar. Gouache, wax and resist. 22 × 14½in

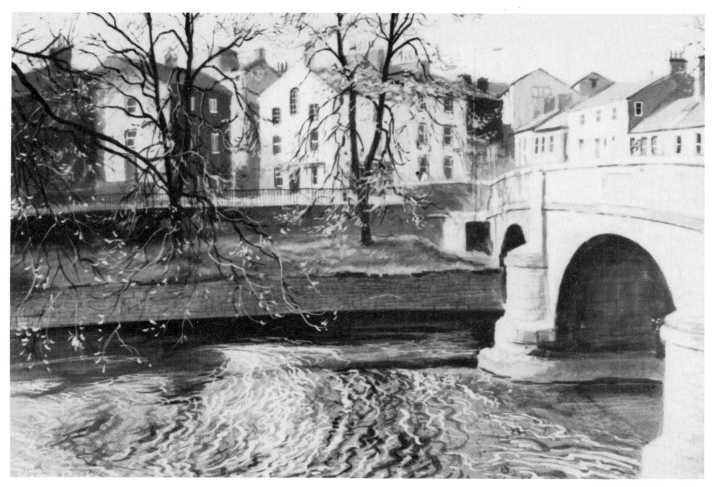

88 *Kendal Spring, Cumbria*. Gouache on grey paper. 14 × 20in

The final spring painting brings us to *Kendal* (*Figure 88*). It relies heavily on the angular shapes of houses and the foreshortened sweep of the bridge across the river. Just below the bridge the water is shallow enough to see a paved river bed, faintly suggested below the surface. Sunlight and shadow predominate, with darker areas showing up the new leaves as in *River at Millthrop*. The sunlight shines under the bridge cutting out reflections, which are only vaguely seen in light and dark ripples beneath the trees.

Looking back over this chapter I notice that the illustrations are nearly all riverscapes. Perhaps this is not a bad thing in that the emphasis is on change of season and weather, rather than subject. Just as the same spot will give you different paintings by changing your position slightly, so will the change of conditions keep your subject fresh. Even the different position of the sun throughout the day turns light masses to dark and vice versa, with the inevitable change of reflections. You may have a favourite season for painting, in which case a good store of sketches and photographs will keep you busy for the whole year. I paint in all seasons, but very often will do a snowscape in summer, one of the many ideas I captured without managing to do it at the time. Really it is a familiarity gained over the years, which enables you to fall into the mood of the scene, irrespective of what goes on outside the studio.

Joint one more point: I have often mentioned working in the studio but by this I do not mean you must have a fully equipped room all to yourself. Obviously it is very convenient to have this, but by carefully choosing equipment and not burdening yourself with unnecessarily large numbers of brushes and different media, etc., it is possible to work without inconveniencing the rest of the household too much. In bad weather it may not be possible to get our during the time you have available, so it is worth organizing an uncomplicated kit which can easily be packed away. A good light is desirable, but I often paint in a mixture of artificial light and daylight, working on the assumption that most paintings are often looked at in artificial light anyway. If you work on the spot or from a car, the problem of a studio will not arise very often, but don't let bad weather stop you from doing bad weather paintings.

CHAPTER SIX
A sense of light

One of the reasons why I love painting water is its reflectiveness. It throws the light back in an endless variety of ways, its ever changing surface acting as a distorting mirror to produce shapes – both recognizable and abstract. Its luminosity can be imparted to the painting itself so that the paper or canvas appears to project light and the surface takes on a burnished look, although this luminosity may or may not be desirable according to the artist's aims and subject matter. A long time after I discovered it was possible to produce, and that it was a quality I wanted, a visitor to my studio mentioned the American Luminists. They were a group of painters working in America in the mid-nineteenth century. Their aims were very close to those I am describing now, and so it is not just an eccentric view on my part. They achieved their sense of light through tonal relations rather than colour, as the Impressionists did, making tone and atmosphere quintessential. How much of this you want to incorporate into your own style of painting is a matter of choice, but here are some examples of my own paintings in which light is significant.

We start with *Winter Afternoon, Kendal (Figure 89)*. This painting was used to illustrate an article I wrote for *Leisure Painter* on painting in gouache. In a section of the article I dealt with achieving a sense of light, and before going on with a description of the paintings it may be useful to quote from it.

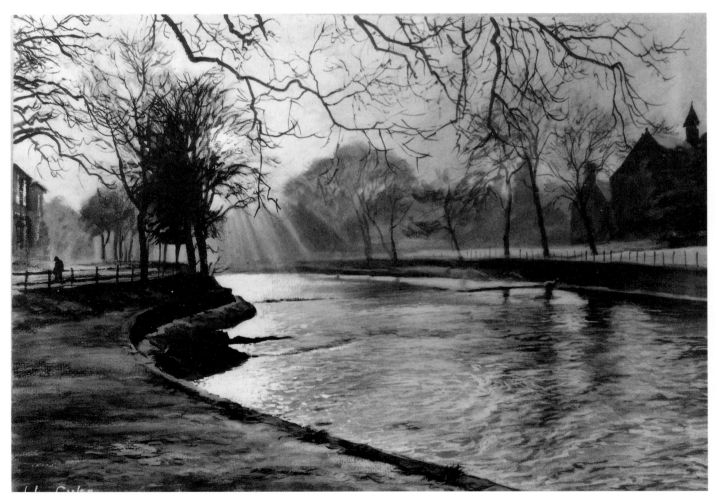

89 *Winter Afternoon, Kendal, Cumbria*. Gouache on grey paper. 14 × 20in

90 *Mill at Tewkesbury, Gloucestershire.* Oils on grey board. 14½ × 19½in

A feeling of light in a painting – almost of light reflecting out of a painting – is very important to me, and for this reason I enjoy painting water, wet roads, snow and white buildings because of their reflective quality. When working on a painting with strong contrasts of light and dark some appreciation of 'eyeball mechanics' is useful.

As we scan a painting, the iris, which controls the amount of light which can fall on the retina, varies very little, if at all. This is because the light reflected off the painting surface is comparatively even. Brilliant sunshine and deep shadow are infinitely further apart tonally than anything that can be depicted in paint. Consequently on looking at, for example, a landscape with lighting contrasts, our eyes are continually adjusting and readjusting to the amount of light they have to cope with. This is what gives us our sense of contrast. Shadow seems deeper because of the light we have just looked at and vice versa.

Now, if the scale of contrast on a painted surface is limited to white paint or paper and black paint (or paper if working on a dark ground), as the two extremes, we must make some sacrifices at one end of the tonal scale to enhance the contrast at the other. My painting *Rainy Evening* (*Colour plate 12*) may show this. The top half consists of great contrast

between light indoors and dark silhouetted door and windows. In reality as the eye roams downwards to the paving our pupils would gradually open to let more light in, consequently allowing more detail to be seen along with quite important contrasts between the light and dark reflections. However, too much light in the bottom half of the painting would destroy the brilliance of the light in the studio, and so a sacrifice is made, allowing the bottom half to be darker than the top half.

The most striking thing in *Winter Afternoon* is the effect of light on the water. I deliberately placed it against one of the darkest features – a group of trees partially hiding the light source, a low sun in the winter's sky. The fact that the sun is partly hidden emphasizes the light on the water, while the dark shadowed riverbank continues this contrast below the trees. In order to maintain the contrast the rest of the painting is played down tonally, neither too dark nor too light, except for dark features such as the overhanging branches, a figure, railings and buildings.

I kept a covering of snow on the foreground riverbank, the far side and the rooftops tonally lower than it would be without such a brilliant reflection. This also applies to light ripples and dark reflections on the rest of the water and the road surface. A haze of light with a few rays

lighten the background and show up tree trunks by the roadside without detracting from the water reflection. A touch of reflected light in windows helps to suggest the luminosity there. The whole point of the painting is the water and its burnished look, achieved through subtle changes in tone as the eye moves across its surface from bright left to darker right – a gentle undulation as reflected trees, then sky, then more trees assert their influence on the water surface. Free brush strokes depicting foreground ripples in light and dark tones (but not too light and not too dark) gradually straighten out and become smaller as the eye moves up and away. I allowed only the bright patch of light to have very light foreground strokes showing the reflected sunlight caught on the moving water.

Mill at Tewkesbury (*Figure 90*) is another picture painted into the light. It is an oil on grey board, with the grey providing some of the middle tones. The mill itself is very dark against a brilliant sun and here I used some black, especially around the edges – a thing I rarely do – to give the fullest possible contrast. I kept all the landscape features very dark in brown and green-greys using Terra Rosa and an Indigo, Ochre mixture along with Burnt Umber. The light is reserved for sky and water with neat white in the brightest parts. A few dabs of Indigo and Umber extend the tonal range in the water as reflections, with some black used in the building reflections. A high viewpoint (from a bridge) allows the river to appear beyond the mill, relieving this dark area. I used Indigo with a little Umber for the middle tone in the sky and windows.

Still on a river subject, but with more diffuse, though still bright lighting, is Figure 91, *The River Cocker*, on the opposite edge of the Lake District to Kendal. This is a monochrome drawing in pen and ink wash on grey paper heightened with white bodycolour. I started it by drawing in the distant hills and trees quite freely with the pen. Next I drew the large tree and some shading over the top area with a brush and clear water which dissolved the ink. I find this is a very subtle way of introducing shading into a pen drawing because it softens the lines and never darkens too much, an easy mistake to make in the early stages. I worked down the paper with pen and brush, softening here and darkening there with diluted ink. The darker washes can be seen in the large tree and opposite bank and in the foreground rocks breaking the surface. Some of this darker tone came from applying a clean brush to newly drawn pen lines.

Only when the complete composition was drawn in did I apply white, first on the sky and then on the main part of the river. The river was very full at the time with a level sweep of water from bank to bank, and so there were few protruding rocks to break the surface or divert the water. This is the lightest part of the drawing and the white was used directly from the tube, producing a dry scumbling effect which I used to suggest slight rippling due to wind and current. As the water breaks around the foreground rocks it becomes disturbed and is also near enough for small detail to be observed; thus I allowed the background grey of the paper to show, suggesting detail by dark and light pen and brush strokes. It is at this point that the reflected light and translucency of the water

91 *River Cocker, Cumbria.* Pen and white gouache on grey paper. $11\frac{1}{4} \times 7\frac{7}{8}$in

comes into its own, with the handwriting of brush and pen allowed to stand as marks in their own right as well as representing water surface. Although simply done, I took care to make the lines follow both the surface form and direction of flow.

The first and second paintings (*Figures 89 and 90*) were done into the light, always a way of achieving strong contrasts. The third has a more diffuse overhead light.

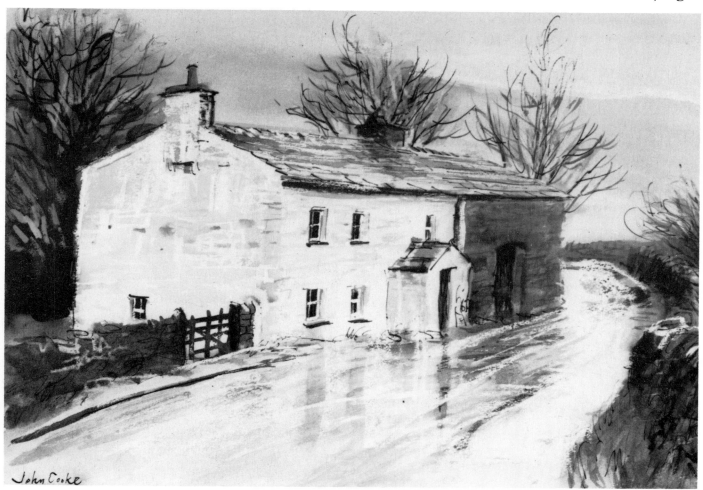

92 *Cottage at Gawthrop, Dentdale*. Pen, gouache and wax. 14 × 20in

Cottage at Gawthrop (Figure 92) is seen on a grey, wet day. For this I used a white watercolour paper as the sole source of light in the painting. First I drew transparent wax into the sky to outline the hill and introduce a texture. Then I made the lines of stone roofing with some suggestion of stonework on the house and light on the wet wall tops and road. The road proved complex as I wanted to suggest wheel marks, the horizontal surface and vertical reflections. Next I brushed on a thin wash of gouache in a light blue-grey. As this dried I added some more wax to the texture of wall, road and roof which helped to retain the blue-grey wash. Then successively darker washes of greys moving from blues to a warmer brown, with wax drawing between, brought the painting to a stage where it was tonally satisfying but lacking in crispness and detail. I therefore used pen, drawing trees, roof walls and windows in with attention to the freedom and handwriting of the penstrokes. In the far left centre I had darkened the trees too much between house wall and painting edge. This could have been scratched out, but I instead chose to paint in a few strong brushstokes of thick gouache to suggest light through the lower branches. I did not do any preliminary drawing, but you could easily plot in sections with a pencil or faint brushmarks.

A sense of light

Another grey day is painted in *Falls at Cowgill* (*Figure 93*). Again I used white watercolour paper but in two distinctly different techniques. The upper half (and therefore distant) uses a watercolour technique with misty effects of wet paint and paper showing through. The lower half (foreground) was completely over-painted with mid-tone washes and then treated as a tinted paper with light and dark painted in thick gouache. This gave a crisp quality to water and rocks in strong contrast to the softer misty outline of the banks and trees. Once again I achieved a burnished look through the subtle gradations of tone from light to dark on the water surface, using reflections and surface ripples. Another way of suggesting radiance is by painting the light striking the flat slabs of rock left and lit edges above the falls centre and on the right.

93 *Falls at Cowgill, Dentdale.* Gouache on grey paper. 14 × 20in

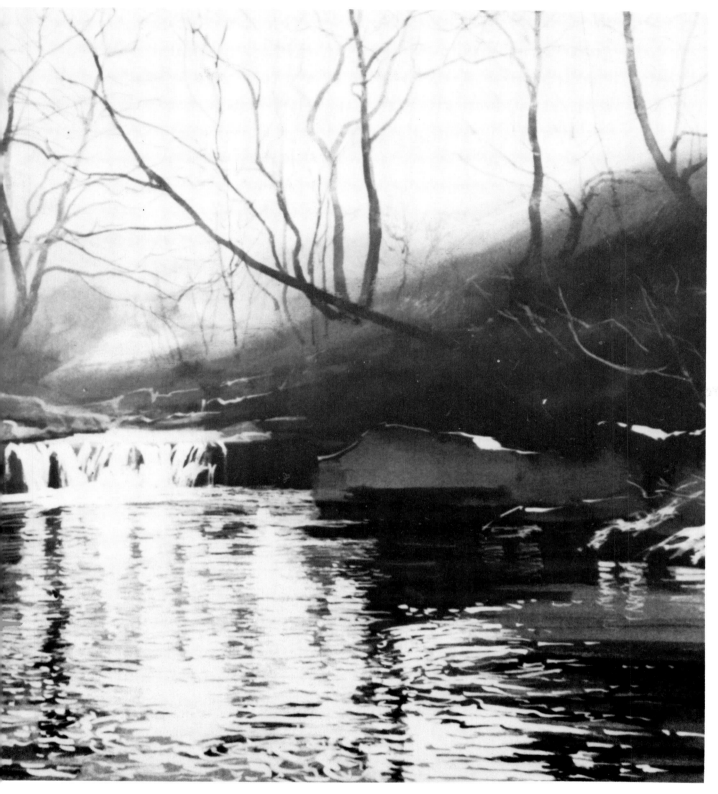

A sense of light

94 *Korthion Beach, Andros, Greece.* Oils on grey board. $11\frac{1}{2} \times 17\frac{1}{2}$in

Returning to head-on lighting, Figure 94 is a beach on the Greek island of Andros with a façade of concrete and a flat-roofed building of the same uninspiring material. However, it was the light which caught my eye, transforming the dingiest scene, so I waded out until waist deep and photographed it.

Back in the studio I decided on an oil sketch and worked very rapidly with paint directly from the tube onto mid-grey board (four sheet). This was unprimed and drew the oil out of the paint immediately, producing a dry, scumbled effect. I used this to soften the roof of the large building with sunlight from just off the picture. Light flecked the waves before me, apparently at random; careful study, however, showed that the highlights were related to the pattern and perspective of the waves, and I adhered to this carefully. Occupying half of the painting, it was important that the waves should be aesthetically depicted as well as lead the eye to the beach.

Also on Andros, the town of Batsi has an attractive harbour with flat roofed shops and tavernas. The nocturne (*Figure 95*) shows what can be suggested with free brushstrokes and very little detail. The emphasis is on the light and the silhouetted shapes and reflections. This is a gouache on grey paper, and I liberally heightened my Raw Sienna with Golden Yellow, touched here and there with green for the artificial lighting. In the water, I painted vertical lines of light and dark, reflecting the windows, in horizontal strokes following the water surface, and the top half of the painting echoes this angularity. The darks were painted in with Burnt Umber and Indigo mixed in varying proportions and thinned in places to allow the grey paper through.

An evening scene of the same waterfront (*Figure 96*) uses a greater expanse of water and, consequently, there is a more noticeable reduction in size of the receding wavelets which catch a low sun from the right. This bathes the buildings on the left, and they and their reflections add greatly to the luminescence of the painting. As a large part is open sky, the vertical reflections are less significant than those in the previous work.

John Cooke

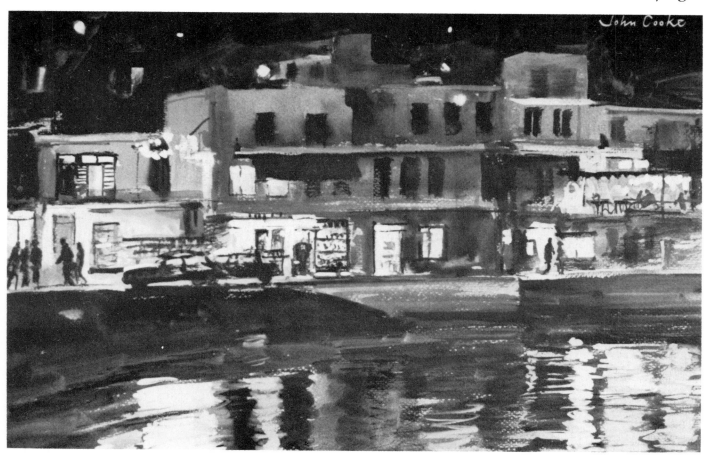

95 *Nocturne, Batsi, Andros, Greece.* Gouache on grey paper. 14 × 18½in

96 *Evening, Batsi, Greece.* Gouache on grey paper. 14 × 20in

97 *Bonfire, Windermere, Cumbria*. Oils on canvas. 24 × 36in

Another nocturne is *Kendal – Evening* (*Colour plate 13*). Here the sky is much lighter but must still be played down to give strength to the street lights and windows and their reflections. The grey paper helps to give background tone as it shows through the thinner washes, but the main emphasis on light is where the reflections are seen against very dark water reflecting the trees. The gouache is softened around the edges with water to allow the light to merge into this background. I used Sienna, Golden Yellow and a touch of Mistletoe Green for the lighting.

In another picture of the Lake District, Windermere (*Figure 97*) is seen on a cold blustery morning with a low sun behind the trees, partially obscured by cloud. It is very similar in its lighting to the Kendal painting (*Figure 89*) but much more expansive, with towering clouds and distant islands. The proximity of bright sun and dark shadows is again the key, although the upper sky and foreground water are much lighter. This is a relatively large oil painting on canvas, and I enjoyed using large brushes on the foreground waves which were lit on the left and shaded on the right. I changed to a smaller brush as the waves receded and the jetty and branches needed to be painted. An appealing detail was the sunlit bonfire smoke on the far shore.

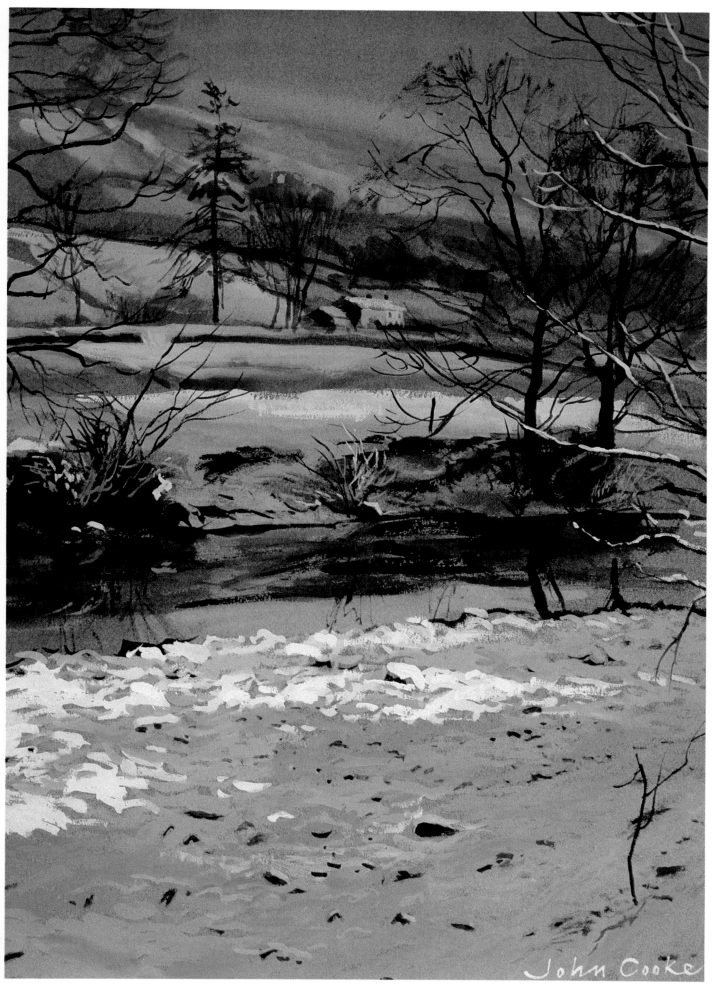

1 *Hugh Croft, Dentdale.* Gouache on grey paper. 16 x 11¼ in

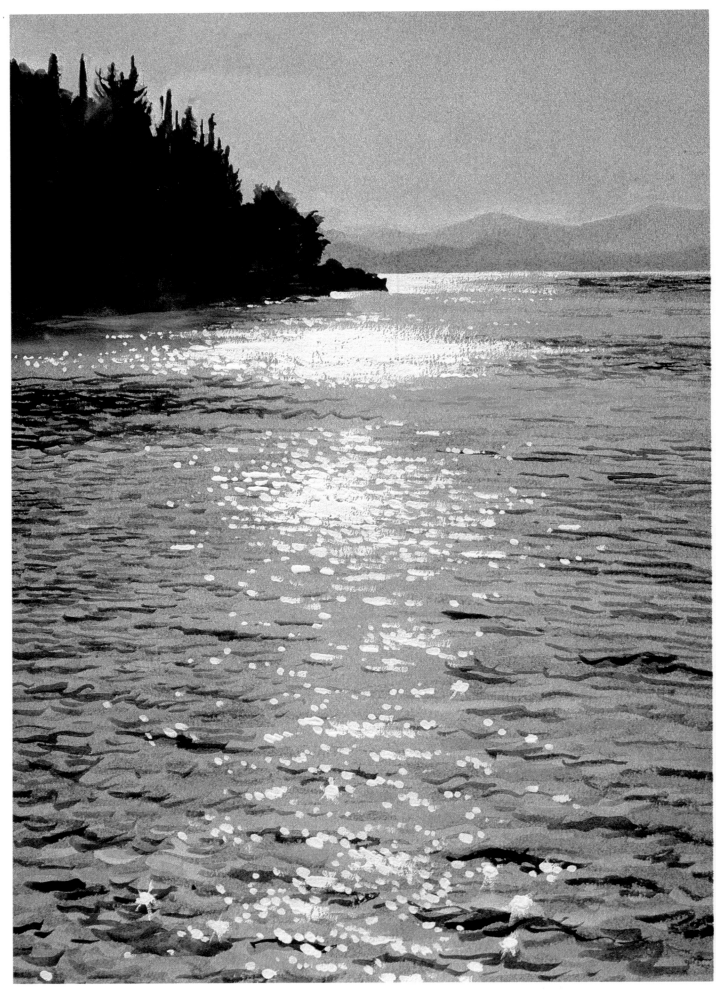

2 *Distant Albania.* Gouache on white paper. 11¼ x 7⅞ in

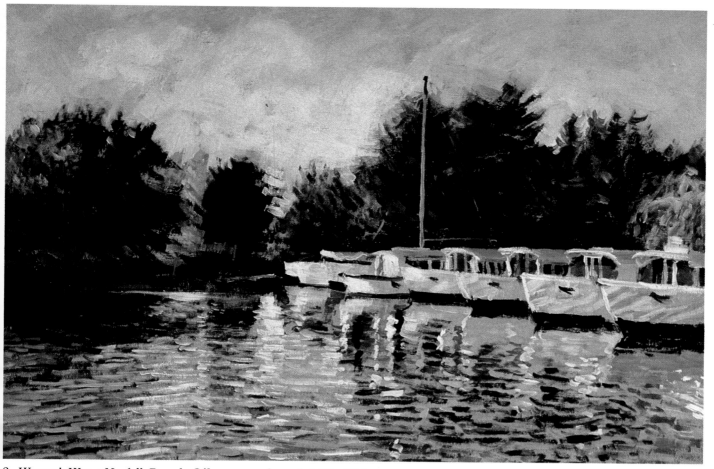

3 *Womack Water, Norfolk Broads.* Oils on grey board. 14¼ x 20 in

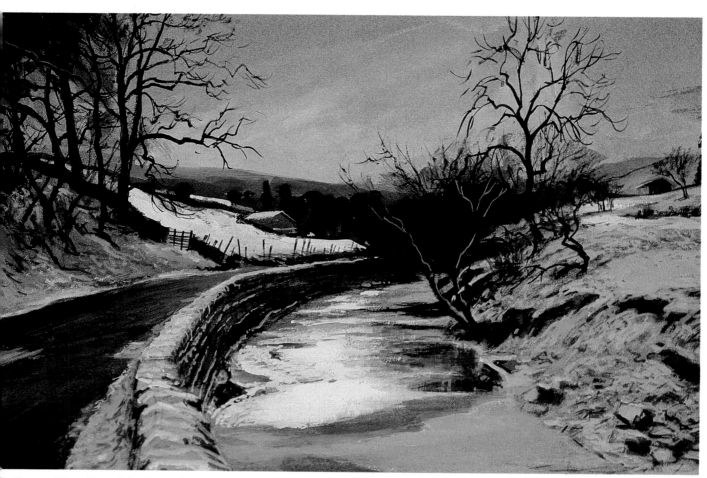

4 *Frozen River, Dentdale.* Gouache on grey paper. 11¼ x 16 in

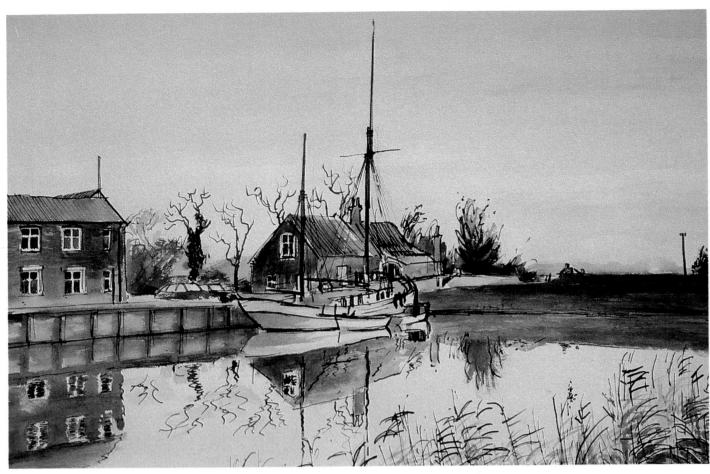

5 *Snape Quay, Suffolk*. Pen and colour wash. 14 x 20 in

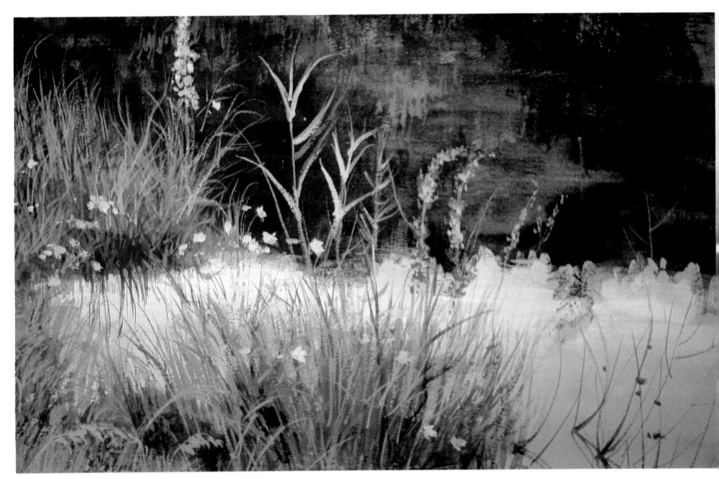

6 *River Rawthey, Cumbria*. Gouache on white paper.

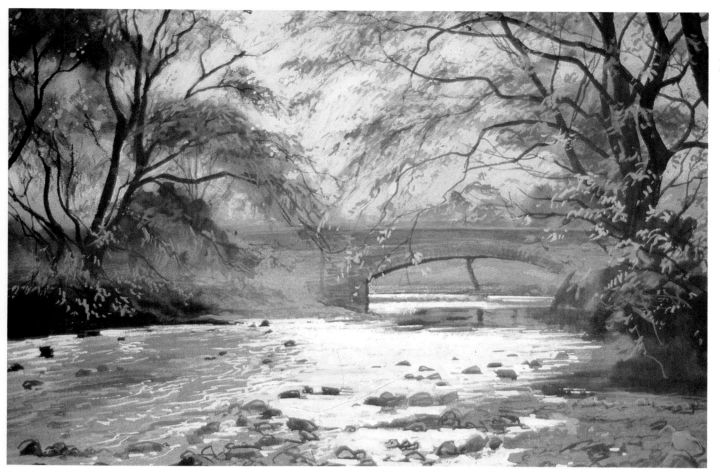

7 *Church Bridge, Autumn, Dentdale.* Gouache on grey paper. 11¼ x 16 in

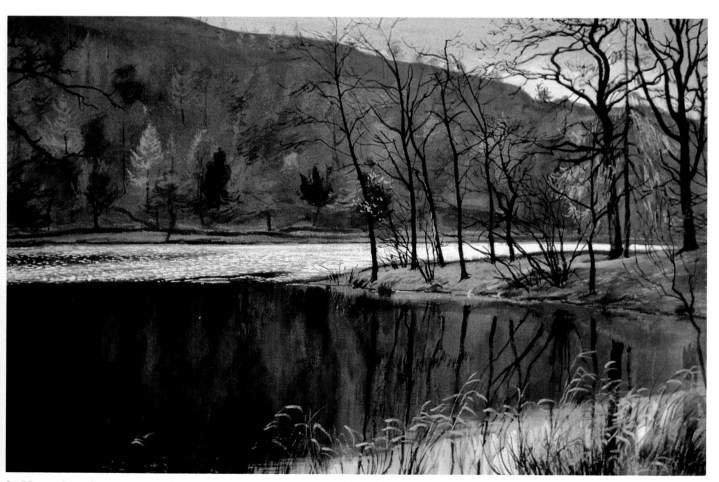

8 *Harry Guard's Wood, Cumbria.* Gouache on grey paper. 14 x 20 in

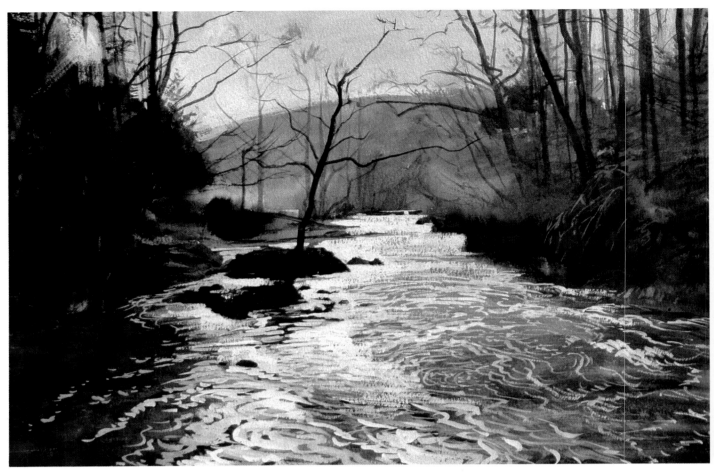

9 *Deepdale Beck, Dentdale.* Gouache on grey paper. 11¼ x 6 in

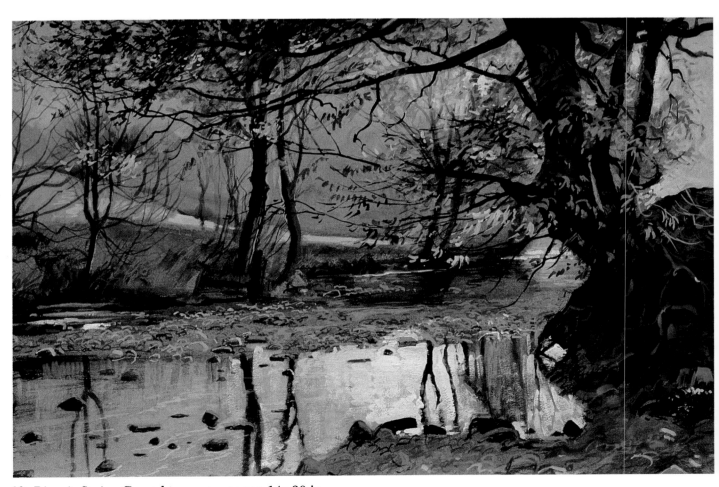

10 *River in Spring.* Gouache on grey paper. 14 x 20 in

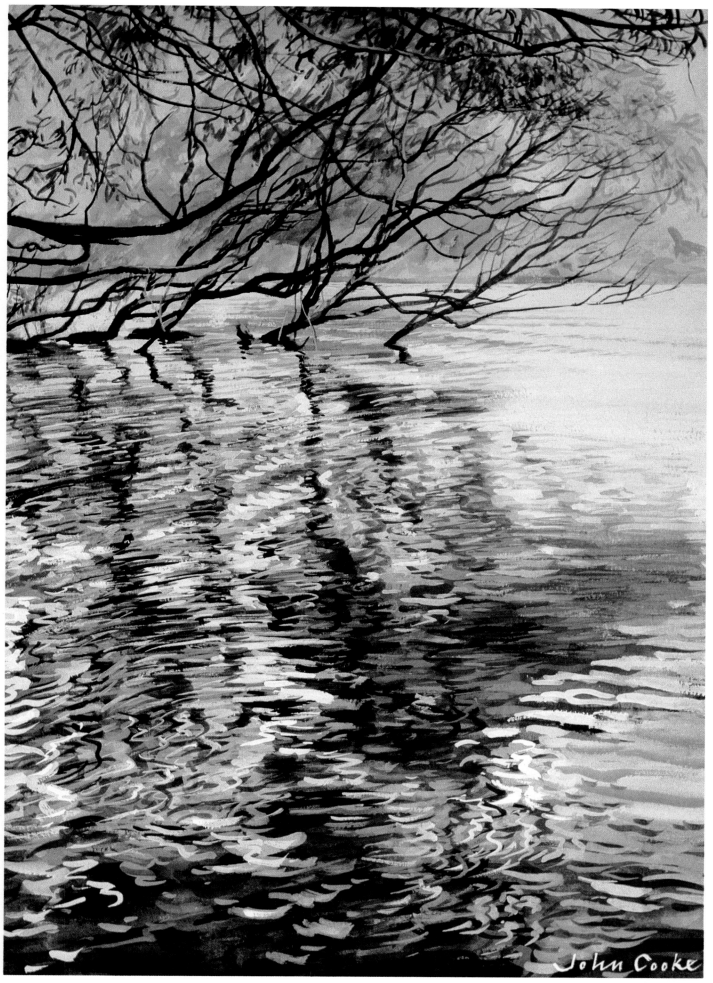

11 *Windermere Shore, Cumbria.* Gouache on white paper. 19½ x 14 in

12 *Rainy Evening, My Studio*. Gouache on grey paper. 19½ x 14 in

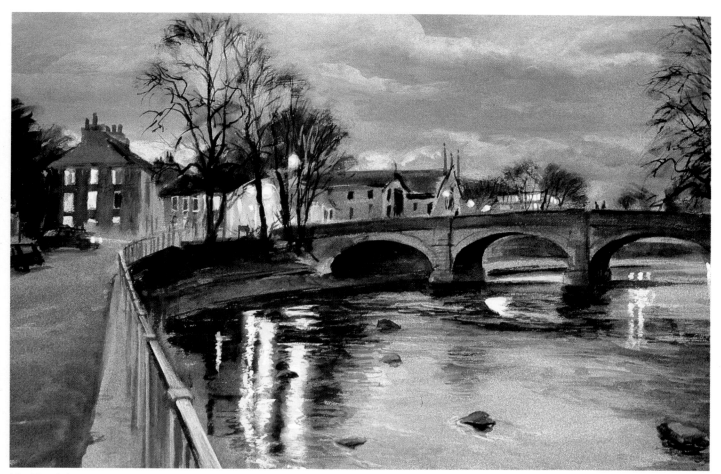

13 *Kendal Evening, Cumbria.* Gouache on grey paper. 14 x 20 in

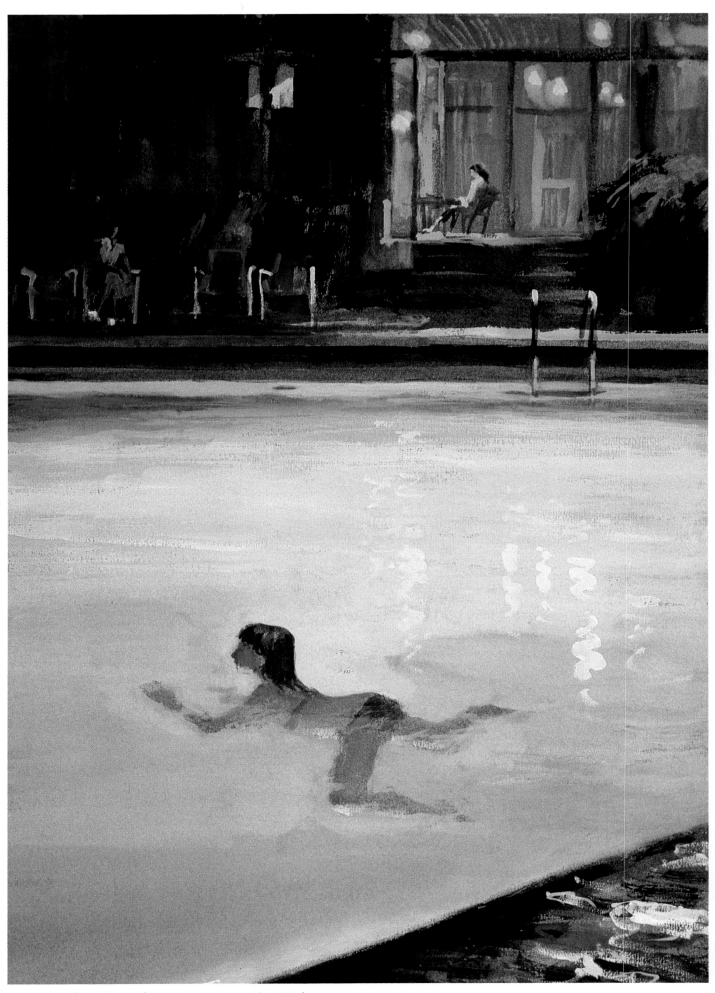

14 *1 a.m. Athens.* Gouache on grey paper. 16 x 11¼ in

15 *East Molesey Locks, Hampton Court, Middlesex*. Gouache on grey paper. 11¼ x 16 in

16 *York*. Gouache on grey paper. 14 x 20 in

17 *From the Rialto, Venice.* Gouache on white paper. 14 x 20 in

18 *The Orwell Bridge, Suffolk.* Gouache on grey paper. 11¼ x 16 in

19 *Windermere and Boat, Cumbria.* Gouache on grey paper. 11¼ x 16 in

20 *Wastwater, Cumbria.* Gouache on grey paper. 14 x 20 in

21 *Pin Mill, Suffolk.* Gouache on grey paper. 14 x 20 in

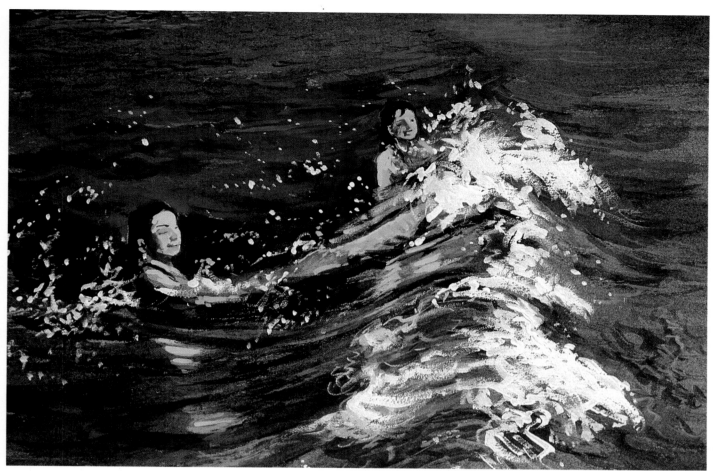

22 *Bathers, Greece*. Gouache on grey paper. 7⅞ x 11¼ in

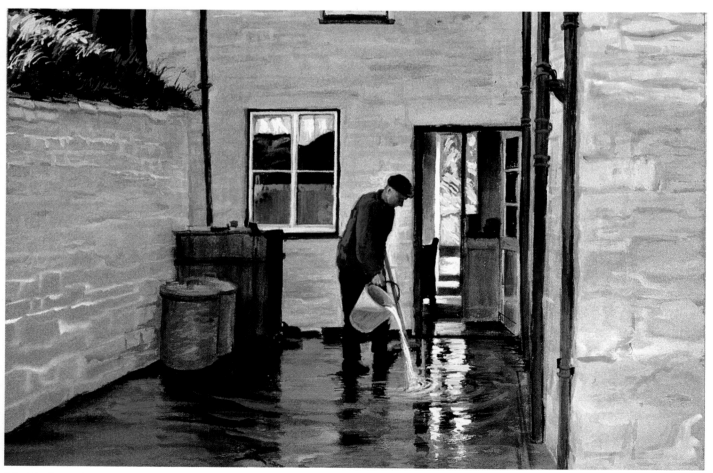

23 *Washing the Yard, Dentdale*. Gouache on grey paper. 11¼ x 16 in

24 *Epping Forest, Essex.* London Transport Poster. Oils on ply. 33 x 25 in

98 *Rash Weir (Blue), Dentdale.* Gouache on grey paper. $7\frac{7}{8} \times 11\frac{1}{4}$in

Colour and light in painting are two different problems, and colour can be indulged in without reference to nature or form. Blue is a very luminous colour and can be used to produce a 'blue' painting in which natural colour is totally abandoned for the effect of juxtaposing various blues. *Rash Weir (Figure 98)* uses the inherent translucence of blue to evoke light, with Periwinkle and Cobalt acting as the mid-tones with grey paper against white light and Indigo and Burnt Umber darks.

Church Bridge (Figure 99) is an oil painting of my home river with tree shadows describing the water surface and the sunlight providing the polish. Another aid to describing the surface are the numerous stones of the river bed, the water being quite low. They diminish in size as they recede (allowing for actual variations in size) in the same way as the waves on Windermere; they catch the light on their right and are shadowed on the left. The sun also lights branches against the dark bridge and raises a mist above the water in front of it. A little finger-smudging here works wonders.

Artificial light and water usually means you are painting street lighting or lighted windows. The swimming pool in *1 a.m. Athens (Colour plate 14)* is a very different situation. My family and I were waiting at a hotel for an early morning flight, and a hot night together with the delicious colour of the pool proved irresistible to my daughter. The water was lit from beneath giving it a wonderfully luminous quality which overpowers the hotel lighting beyond but allows surface reflections in long wavy lines. The figure is lit from below, and the light source from *within* the water produces an unusual effect.

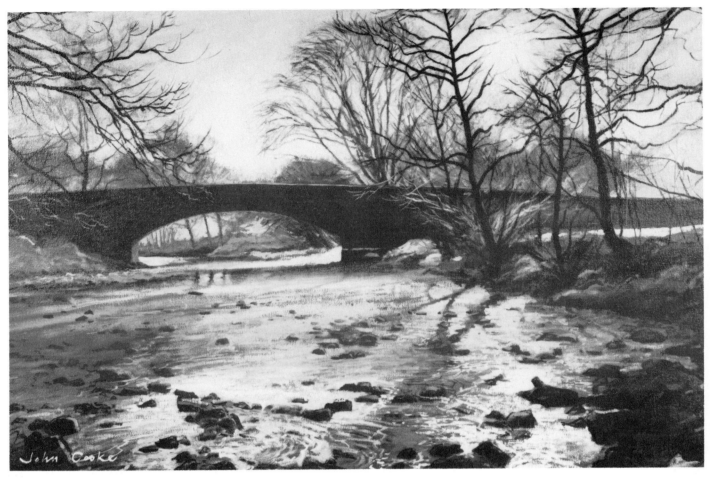

99 *Church Bridge, Dentdale.* Oils on canvas. 20 × 30in

The direction of lighting is instrumental in a composition. The main directions are, of course, head on, from the side or from behind the viewer. It may be a mixture of one or more of these or it may be diffused by a cloudy sky of filtered through leaves. Probably back-lighting gives the least interesting effect. It does not offer any side shadows to help describe the form of an object and so flattens the general appearance. Most exciting, I think, is painting into the light: it produces strong contrasts, with dark silhouettes against brilliant light. (There are a number of examples of this technique in this and earlier chapters.) One of its limitations, however, is that it cuts down colour with its tonal extremes, whereas lighting from behind enhances colour. The best of both worlds of colour and form comes from side-lighting. On water,

head-on lighting gives sparkling highlights dancing on the surface, side-lighting does this to a lesser degree, while light from behind the viewer simply shows up the colour without any highlights. A deep blue sea usually results from light from behind.

I hope a sense of light pervades most of my work and that the examples in this chapter show you how I achieved it. If you pay attention to tonal relations and the sacrificing of some contrasts in order to enhance others, this luminosity can be achieved to a greater or lesser degree according to your requirements. A little time spent in putting these ideas into practice will help you decide how much light you want in the painting and how best to achieve it.

CHAPTER SEVEN
Source material

Source material for waterscapes can be found in a variety of environments, and I should like to give a number of examples of my paintings done from ideas collected from different surroundings. All paintings, whether abstract or figurative, must have a starting point – something which sparks off an idea in the painter's mind. With landscape this is usually the live experience of seeing a particular view at a particular time under certain conditions.

Most of my ideas for waterscapes come from my own doorstep as I live within easy striking distance of streams, falls, rivers and lakes. When I travel further afield I usually manage to collect a few ideas to bring home and work out in my studio and I am sure that most people who appreciate the changing light and conditions which affect water so much have access to stretches of water capable of producing interesting paintings.

Whether you live in the country or in a city, canals, ponds, reservoirs, fountains or streams are never far away. Water is essential to human settlement and habitation. The only distinct difference between rural and urban water is that the former can be rough and turbulent in natural surroundings, a condition only artificially induced in urban and suburban areas in the form of weirs and locks. Urban water can be somewhat turgid but nonetheless beautiful in its light and reflections. The canals of Venice are a good example.

I have an annual London exhibition and one day I left Waterloo station, armed with my faithful Rollei and followed the embankment towards my gallery in May-

100 *Westminster*. Oils on canvas. 16 × 24in

fair. I photographed as I went along, collecting maybe half a dozen shots. Back home in the studio, I sorted through them and, after settling on one for a painting, trimmed it down to the scene I required. This stage was an important part in composing the picture, even though I had not touched a brush yet. *Westminster (Figure 100)* shows the urban waterscape *par excellence*. Dominated by manmade structures and bustling with river commerce, its atmosphere is very different from the tranquillity of a rural stretch of water. I used oil on canvas, and the ochres and browns, slightly toned down with Cobalt Blue and Indigo, give a colour range suggesting stone buildings and their reflections in brownish water. I allowed some of the early drawing, done with a No. 2 nylon oil brush in Raw Sienna, to show, outlining the well-known skyline, which I painted in a free, Impressionistic way. I filled in the larger areas using a No. 8 chisel-shaped nylon brush, notably the sky and water, having first darkened the sky with Cobalt and Burnt Umber and then brought up to the required tone with these colours and a little Yellow Ochre mixed with white.

I painted the waves to recede in size towards the far bank, and a certain amount of tonal perspective is evident in that the darkest reflections are in the foreground. In the distance, Cobalt Blue helped to keep the Abbey far behind the Palace and Westminster Bridge. Red and blue decoration on the boats relieved the pervading colour of stone.

Away from the city and a few days later, I followed the Thames along a bridle-path east from Hampton Court. *Molesey Locks (Colour plate 15)* is typical of suburban waterways and, though only a narrow stretch, I arranged the composition to allow the water to occupy a large part of the picture. Again my camera provided the memory aid as time was pressing and I wanted as much information along this stretch of river as I could gather. This time I used gouache on grey paper and I started in my usual way by washing in the sky with a pale white-Indigo mixture, leaving out the shapes of skyline trees. As the scene progressed towards me I gradually darkened the tones, painting in trees, sometimes with a No. 8 sable, sometimes a No. 2 Daylon brush. I introduced a little Periwinkle here. It can add vibrancy to the quietest greys and really is a lovely blue. I muted the tones of distant boats and buildings up to the nearby trees and lock-keeper's lodge.

Even subdued lighting produces light and shade, and the three-dimensional quality of the building is upheld by a soft light from the right. The trick is to suggest shadow on the same colour, rather than changing the colour, as you actually do. For instance, the white-painted rim around the roof must appear white all the way round, although I painted the left side, in shadow, in a pale blue-grey of white, Cobalt Blue and a little Burnt Umber.

Raw Sienna, toned down with other colours from the palette (which consisted of the afore mentioned colours plus Alizarin Crimson and Prussian Blue) was used for the surface in front of the lodge, with a pale wash of green (Prussian Blue and Raw Sienna) for the grassy bank beyond the lock. I used a lighter version of the Sienna for the vertical lock walls, with darker mixed greys for the

jointing and staining. Little strokes of light on the figures maintained a sense of light from the right.

The water made a stimulating subject, being a little disturbed after filling the lock, with distorted reflections and small currents and eddies. I find that on grey paper it is useful to paint an all-over wash of light colour onto the light areas. This dries with the paper showing through, giving a background for thicker paint following the lines of ripples. Here, the olive green of the water is a mixture of Prussian Blue, Sienna and Umber of varying tones, and the very dark areas are Indigo and Umber. Under the lock gates some light is reflected up from the water, and a little Periwinkle mixed with the above colours sufficiently differentiated the hue from the main body of water.

Although both in an urban environment, York and Venice differ climatically and architecturally. Being non-industrial, however, they share an ambience of leisure, with their waterways used for recreation and pleasure. The river at York is very accessible, having plenty of tow-paths and walkways, so it is a good place to go looking for riverscapes.

Painted in gouache on grey paper again, *York (Colour plate 16)* has a certain amount of warmth in the brick buildings for which I used Crimson and Sienna, but the overall atmosphere is of a coolish day, with grey skies and autumn trees. The river is wider than in the Molesey painting and suggests a greater recession in the perspective of its surface. The light ochre stonework is slightly darker in its reflections and these, against the dark water, gave me an opportunity to produce a polished effect on the surface. The reflections of the ochre retaining-wall and the white posts gradually break up as they descend into the water, the brushmarks following the curve of the current. The two boats passed by at different times, but were used together, carefully arranged in position and direction to follow the perspective of the surface.

I was in Venice for only a few hours between a ski-ing holiday and the flight home, so once again the camera was indispensable. It is one of the few places I have been to which turned out to be exactly as I had imagined from books and photographs, so it was not difficult to feel in tune with its breath-taking beauty. I walked with my wife and daughter across the city, enjoying intriguing glimpses of narrow waterways and high balconied windows. On crossing the Rialto Bridge we saw the gondolas, and a scene which had to be painted *(Colour plate 17)*. The sky was slightly overcast, precluding any strong shadows, but the golden light reflected off ancient buildings into the Grand Canal, giving a warmth to the scene.

I chose white paper, brushing a Raw Sienna wash of thin gouache over the top third, gradually changing to a greeny-blue which I darkened towards the bottom. Onto this ground I drew the houses in a free brushline with a No. 2 Daylon. When worn a little, these brushes produce a line thick enough to paint distant windows and reflections in a single stroke. With a newer brush I finely drew the eaves and rooftops and sketched in the gondolas. The beautiful shapes of these very specialized boats are a delight, and I set to work on them after having painted in some darker wavelets. The background light is almost completely the original wash of Sienna with white paper showing through, but the foreground has heavier

101 *Potteries Canal, Staffordshire.* Pen and colour wash. $11\frac{1}{4} \times 16$in

applications of light paint on darker washes. I used this thicker paint to correct the drawing of the gondolas where necessary – for example, the bows of the nearer one. Some of the Sienna was brought into the foreground water, picking up the light here and there, interspersed with dark grey and blue greens (Prussian, Sienna and Umber). I used a little Crimson and Ultramarine in the building in shadow on the left and in the light grey on the gondola bows. Notice the touches of light through translucent water beneath the bows and stern of the nearer boat.

There is a complexity of rippling in the foreground owing partly to other boats passing through and partly to the manoeuvering of the gondolas. I followed these with free brushstrokes (a No. 8 sable), trying to keep the crests light and troughs dark. In this situation I was glad of the overpainting characteristics of gouache to correct errors of judgement and work the water up into a convincing pattern following the laws of surface mechanics – namely, that any disturbance will send its ripples far and wide so that beneath apparent chaos, there is an order which can be very difficult to fathom. The best way is to simplify this, and often one brushstroke will suffice for several ripples.

Industry provides an interesting background to water, and I particularly like the derelict old buildings along canal banks, where once thriving factories now present empty windows. Their air of melancholy is an appealing

contrast to more prosperous scenes. *Potteries Canal* (*Figure 101*) was drawn in pen with a water soluble ink and colour washed, so softening the line in places. A wet brush drawn across the water surface picks this up along with the colour to help indicate calm water.

I said earlier that I was brought up in Stoke-on-Trent, and at that time, it must have been the original Dirty Old Town. I remember it now with affection, but having

102 *Suffolk Stream*. Gouache on white paper. 14 × 20in

lived in the country for many years I feel a greater affinity with my natural landscape and enjoy the free shapes and arabesques of the rural scene. I then moved to Suffolk, and the stream portrayed in Figure 102 is typical of the little secluded waterways of this county. I used a palette of gouache including Fir Green and Viridian. These colours tone down well with browns and reds and have less of the acid bite of brighter greens.

The sky is a pale wash of blue-green (Indigo was the only blue used), and Raw Sienna helped to lighten the green and introduce a pale sunlight to the background trees. I left white paper as a cloud bank above the horizon. A few dead trees gave an appealing linear quality to an otherwise dense mass of foliage and vegetation. I painted it very freely with the individual

brushmarks standing in their own right, as well as suggesting details of the landscape.

After darkening the water reflection with greens and browns, sometimes blended on the paper, I reintroduced light with thick white gouache, outlining in the reflected shapes with a mixture of vertical and horizontal strokes. Some white paper remained showing at the bottom of the composition. I added a distant cornfield and some more light in the trees with Sienna and white. Finally, Indigo, subdued with a little Burnt Umber, picked out one or two dark areas, fully extending the tonal range. Above I mentioned blending paint on the paper. This is a good way of mixing while retaining some of the original colours in a soft, textured way.

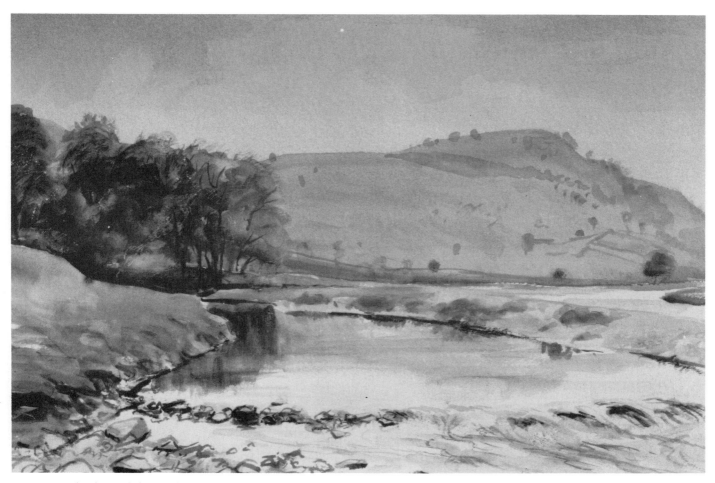

103 *River Wharfe, Yorkshire Dales.* Watercolour. 14 × 20in

Rural areas in Britain are very different geologically – for example the Pennines compared with East Anglia. In beautiful Wharfedale the river sweeps down in wide, shallow curves, held back in places by primitive weirs of loose boulders. My painting of *The River Wharfe (Figure 103)* is a watercolour done at a point where the river divides around an overgrown shingle bank, built up on the flood plain. I started this painting by washing in the dominant hill with a blue-green grey of Cobalt, Raw Sienna and Burnt Umber. While this was drying, I worked on the lower half, drawing in the shingle bank and stones with a fine brush in pale grey and then washing in Raw Sienna. When the hill was dry I returned to it and indicated the dotted trees with a darker version of the grey, using a No. 8 sable brush. Then I mixed a mid-tone grey-green with Lemon Yellow, Prussian Blue and brown to darken the area of the large trees. Returning to the lower part, I added green to the shingle bank and the slope on the left. Some slightly darker greys, browns and ochres gave texture to the hillside before I returned to the nearer trees, painting in trunks and branches and the dark shadows. A blue-grey wash across the water surface mirrored the hill, and dark browny greens the trees. Next I worked on the little weir, outlining the shaded sides of stones and painting the water flowing over. When dry, the hill reflection had too sharp an edge, so I softened this with a brush and clean water.

I decided that the trees were, however, too dark and I washed out areas where the light was striking them, blotting the paint out with a clean tissue. Into these I painted Lemon Yellow which, together with the remaining pale blue-green, gave a brighter green. A little more Sienna in the shingle bank and foreground stones added warmth to the picture. I still needed to lighten the dark areas and with a sharp knife blade I scratched into the trees and the left-hand bank, adding a little Lemon to some of these white marks.

Notice that the whole scene is one of calm and tranquillity, contrasting with the previous urban paintings. An interesting feature of the weir is its varying height which allows water to flow over on one side, but holds it back on the other. Although a green painting, there was no green on my palette.

104 *River Urquhart, Scotland*. Gouache on grey paper. $7\frac{7}{8} \times 11\frac{1}{4}$in

Figure 104 shows the River Urquhart in full spate – what canoeists would call 'white water'. I used Fir Green with my usual gouache palette for the background trees, and the hillside has Ultramarine along with Umber and Sienna for the shadows. The water is liberally impastoed with very thick white straight from the tube, while the water flowing in shadow from the left has Prussian Blue to liven it up together with mixed greys. A little Crimson warmed up the rocks with Sienna light on top (both toned down with my Umber and Indigo grey). Sadly, I had no other Scottish waterscapes available for this book, for it is a country of wild and beautiful water, well worth visiting for painting.

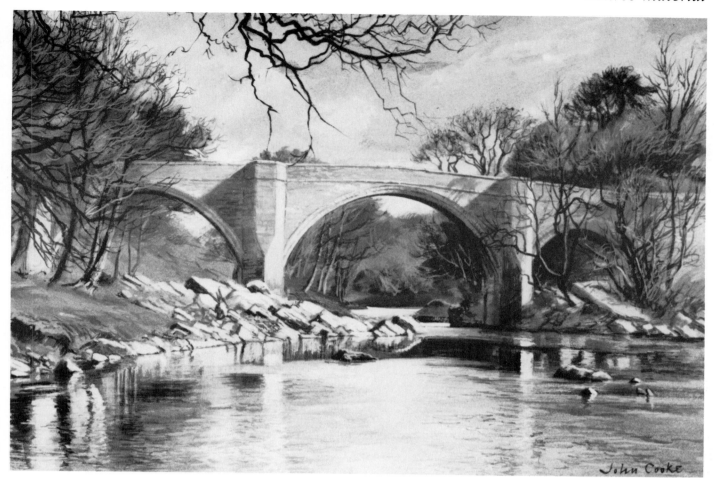

105 *Devil's Bridge, Kirkby Lonsdale, Cumbria.* Stage 2. Gouache on grey paper. 14 × 20in

Where there are rivers there are bridges. These can provide beautiful and exciting compositions with their varying spans and building materials. Two strongly contrasting examples are seen in the Orwell Bridge (*Colour plate 18*) and the Devil's Bridge, Kirby Lonsdale (*Figure 105*). The former is a modern construction in concrete, spanning the River Orwell below Ipswich. It is quite stunning in its scale and elegance, and I painted it from below and a little to one side, so that it soared above me with the sun illuminating its side and pillars. The tide was low, so I could paint water and wet mud banks, both reflecting light in their own particular way. Distant clouds caught the sun as well, their free lines echoed in the far trees and again in the foreground mud. Water and bridge both show strong light, and so the colours used, Sienna in the bridge and a light mixture of white and Prussian Blue in the water, are very important – one being warm and the other cold.

106 *Devil's Bridge*, Stage 1

The Devil's Bridge displays its elegance much more modestly. Built in local stone, it has mellowed into the landscape and spans the River Lune at a narrow point where rocks pick up the bridge colour and reflect into the water. Stage one (*Figure 106*) shows how I approached the painting, washing in colours freely onto the grey paper and leaving the bridge itself until later, having sketched it in lightly with a brush. It has a different appeal to the Orwell Bridge, but within the scale of its surroundings has a presence of its own, seeming to grow out of the landscape, rather than being imposed on it.

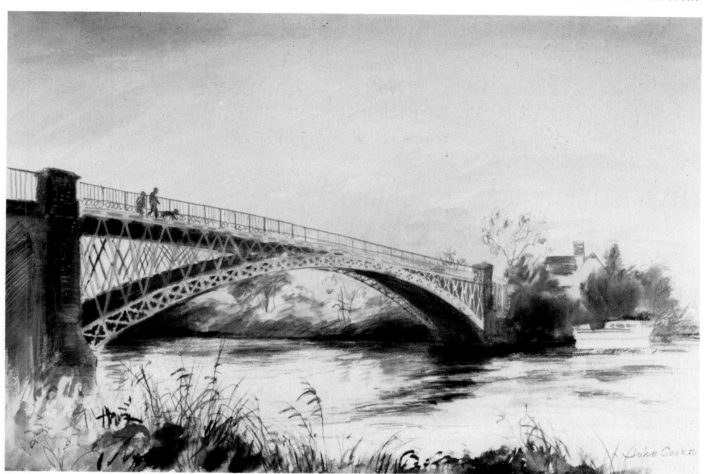

107 *Telford's Bridge, Tewkesbury, Gloucestershire.* Gouache on white paper. $16\frac{3}{4} \times 21\frac{1}{2}$in

The Telford Bridge over the Severn at Tewkesbury (*Figure 107*) is made of iron in a complicated cantilever construction. This can be rather daunting to paint so try to avoid detail without losing the appearance of intricacy. The water surface is disturbed enough to prevent any clear images, and the only reflection is the dark underside of the bridge. Foreground grasses make an interesting pattern against the light water.

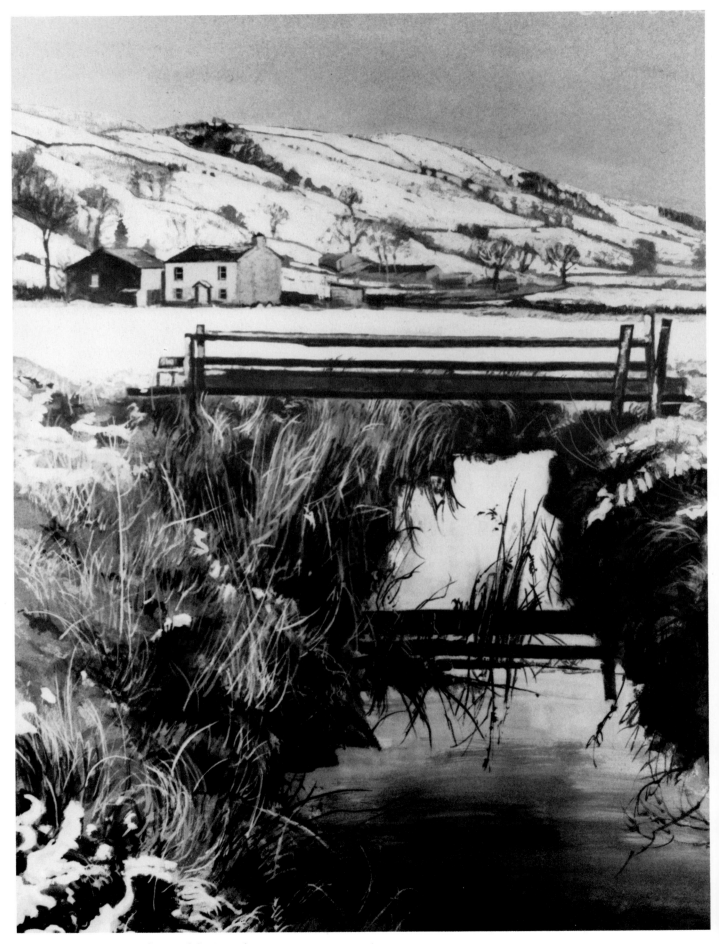

108 *Footbridge at Outcroft, Dentdale.* Gouache on grey paper. 14 × 20in

109 *Windermere*. Gouache on white paper. 14 × 20in

I cannot leave the subject of bridges without including a little favourite of mine. The footbridge at Outcroft (*Figure 108*) is a charming wooden construction crossing a drainage dyke on the meadows near my studio. The water here is calm and sheltered even on windy days, creating clear reflections. It darkens gradually nearer to, reflecting a blue overhead sky which is above the top edge of the picture. Browns and yellows were used in the grasses and the house, adding warmth to a winter's day.

The wide expanses of water shown by lakes pose different problems to the river scene. Surface characteristics diminish with distance until waves and sparkling light merge into narrow strips which themselves follow the rules of foreshortening and perspective.

In *Windermere* (*Figure 109*) the nearby reflections have a distinct shape. The rest describe the level surface and wonderful feeling of space and light, aided by a slightly darker sky. I tinted the whole of the white paper with a blue-grey wash. I then painted the sky in thicker, lighter gouache, carefully outlining the hills as I did so to leave the background colour showing. I allowed the tone to darken higher up by thinning the paint and outlined the tops of distant clouds with the lighter paint. I treated the water similarly, with bands of light widening as they came nearer until surface details became evident, as in the reflections below the islands on the right.

This painting was done from a relatively high viewpoint, but another painting of Windermere (*Colour plate 19*) shows the lake from water level and the recession of waves is more notable. It was a cold day and the choppy water darkened after the first few hundred yards, the remaining few miles being contained in a narrow dark blue band. Sunlit reeds, a distant sunlit bank and snow-capped hills captured the winter sunshine.

Source material

I have a strong feeling for hills and mountains, having been introduced to them as a teenager and discovering, through walking and climbing, a landscape which I strongly responded to. As a student I would sadly neglect my painting in order to indulge in mountain activities, and though this did not help my work directly, it made me understand many aspects of mountain scenery.

Water is very much a part of this, and streams, lakes and tarns are never far away. They have a different quality to lowland water in that the streams always seem to be rushing over falls or lying in dark, rocky sided pools and the lakes and tarns are dominated by grand reflections, cutting out the sky.

The stream in *Mickleden (Figure 110)*, the upper part of Great Langdale, is a typical Lake District beck. Seen here after heavy rain, it runs into view just below eye level, dashing towards us over little falls and around boulders before rushing over the foreground step to the pool below. I painted this mostly in thin washes of Indigo and Burnt Umber, with a touch of Raw Sienna added at later stages. The paper gives an all-over greyness to the land, appearing in the rocks without any paint cover. The sky is a thin wash of white, blending at the bottom edge with the hillside, and the running water is thick white gouache, in strong contrast to the rest of the painting. The two climbers remind me of many days of hill walking in sodden clothes, with shoulders hunched up against wind and rain.

Moorland has a glorious open upland quality all of its own, and its streams are isolated and lonely little threads of water. *Flintergill (Figure 111)* washes the walls of my studio as it descends through our village, and its upper reaches run over bare moorland. It is this latter view that I chose for the Shell Wildlife Habitat Calendar. I painted this in gouache on white paper, tinting it first with the browns, ochres and greens seen on the hillside, with blue on the upper part. As a subject it was intended to emphasize the lonely beauty of high moorland, so a very high skyline left plenty of space for the bleak hillside with its narrow stream. The stream cuts through foreground rocks, descending in little falls into a pool of a lovely blue-green. I used Viridian and Mistletoe for this, along with Prussian Blue to give a strong, rich colour. A touch of heather colour, partially sprayed on with a stiff brush and knife blade, together with the curlew, that bird of the lonely moors, helped to relieve an empty landscape.

After painting the bird in, I painted the sky up to it, drawing with the edge of the paint, as I did with the Venice gondolas, and so preventing a 'stuck-on' appearance.

Figure 112 depicts a very different scene. The mountains around Kentmere are not very high, but when covered with snow and bathed in sunshine they assume Alpine proportions. Calm patches in the tarn reflect snow, but where the wind disturbs the surface, it gleams darkly, catching the light again where waves become visible nearer to. I reserved the brighter tones for only snow and cloud tops.

Another example of dark mountain waters is *Buttermere (Figure 113)*. Here it is the disturbed surface which catches the light, the rest mirroring the grand

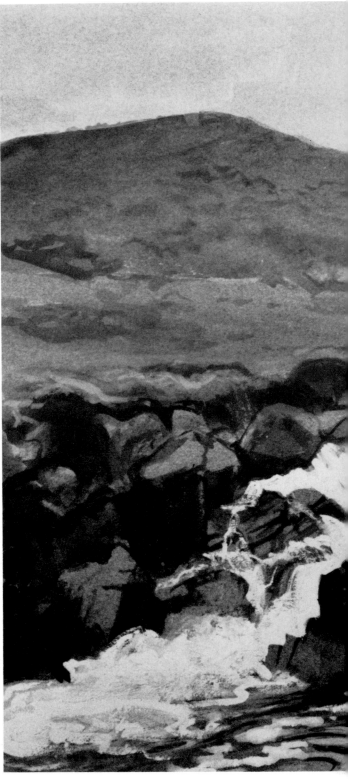

110 *Mickleden, Langdale Valley, Cumbria.* Gouache on grey paper. $11\frac{1}{4} \times 16$in

shape of Haystacks and the famous Buttermere Pines, beloved of postcard photographers and painters alike.

Mountain waters are not always dark. *Wastwater (Colour plate 20)* and *Rowan and Tarn (Figure 114)* both reflect a dazzling light because we are looking away from the immediate hillsides and the direction of light is just right for this effect. The brightness in both paintings is relieved by silhouetted trees. The foreground of *Rowan*

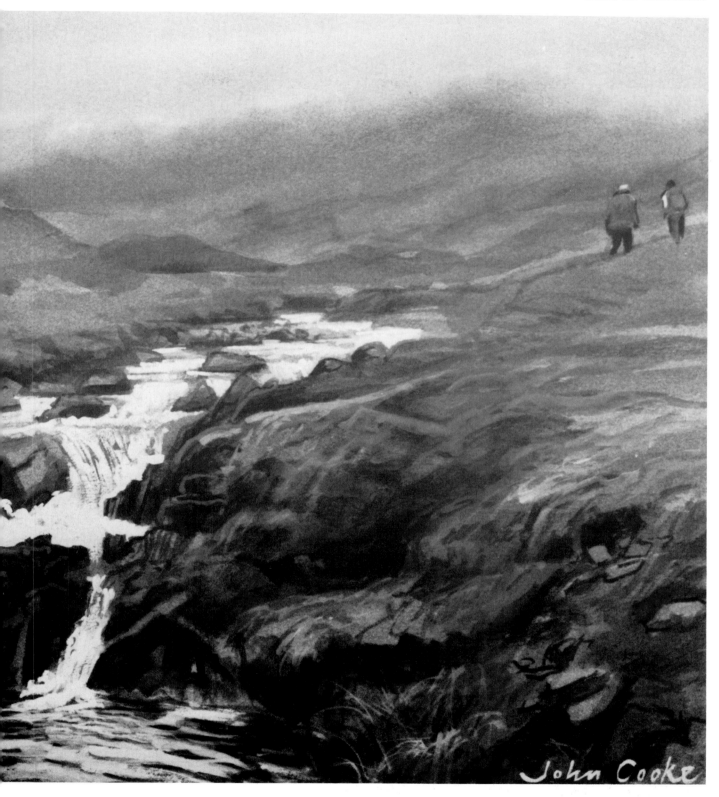

and Tarn gains interest from the reflected tree, while Wastwater has warm tinted bracken, light against the dark shadows and dark against the lake.

An obvious place to look for waterscapes is the coastline. There is a fine distinction between water in the landscape and marine painting. The latter is highly specialized, requiring intimate knowledge of ships and seafaring, but we are all attracted to the seashore in search of recreation.

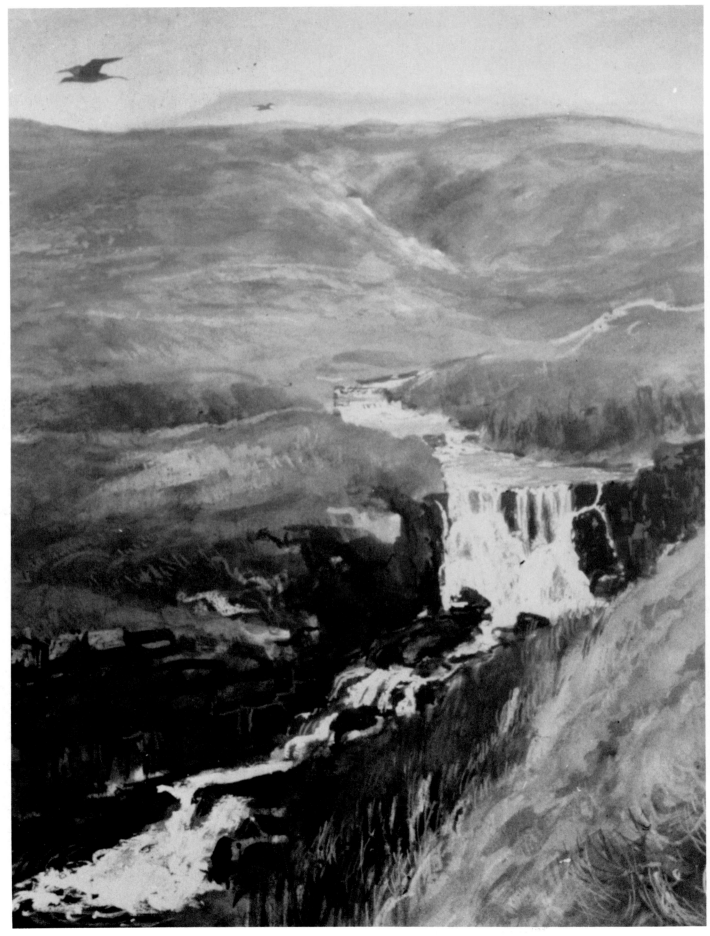

111 *Flintergill Moorland, Dentdale*. Shell calendar. Gouache on white paper. 20 × 18in

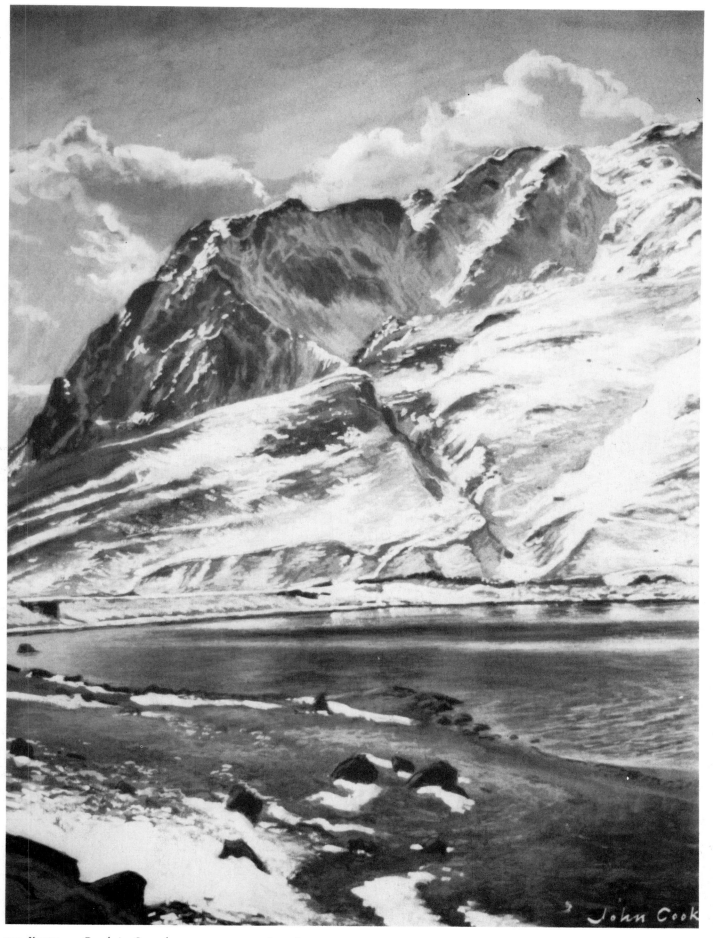

112 *Kentmere, Cumbria.* Gouache on grey paper. $19\frac{1}{2} \times 14$in

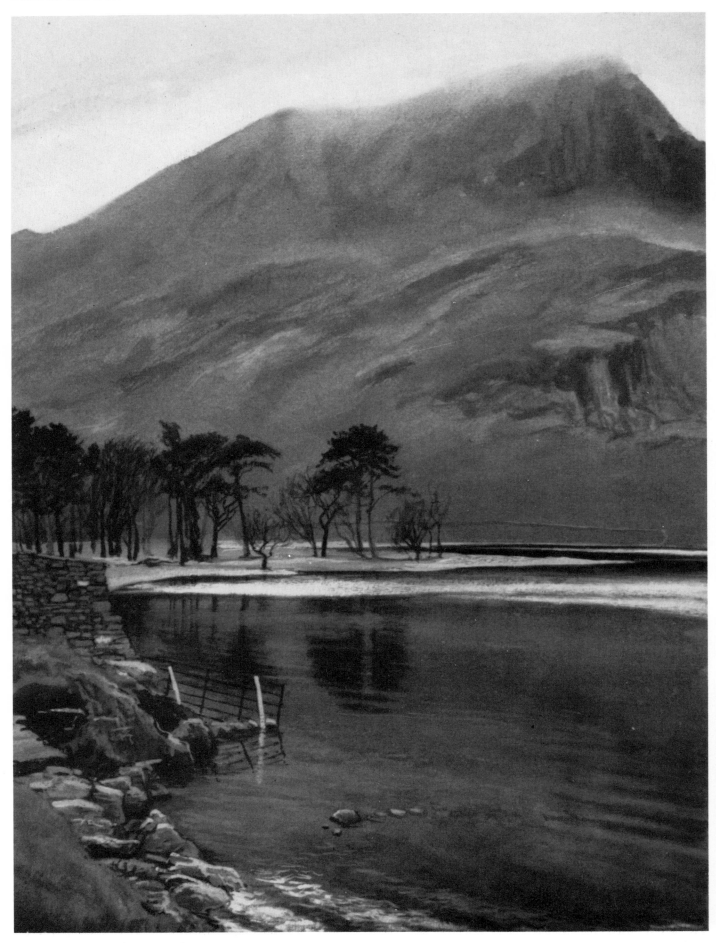

113 *Buttermere, Cumbria.* Gouache on grey paper. 19½ × 14in

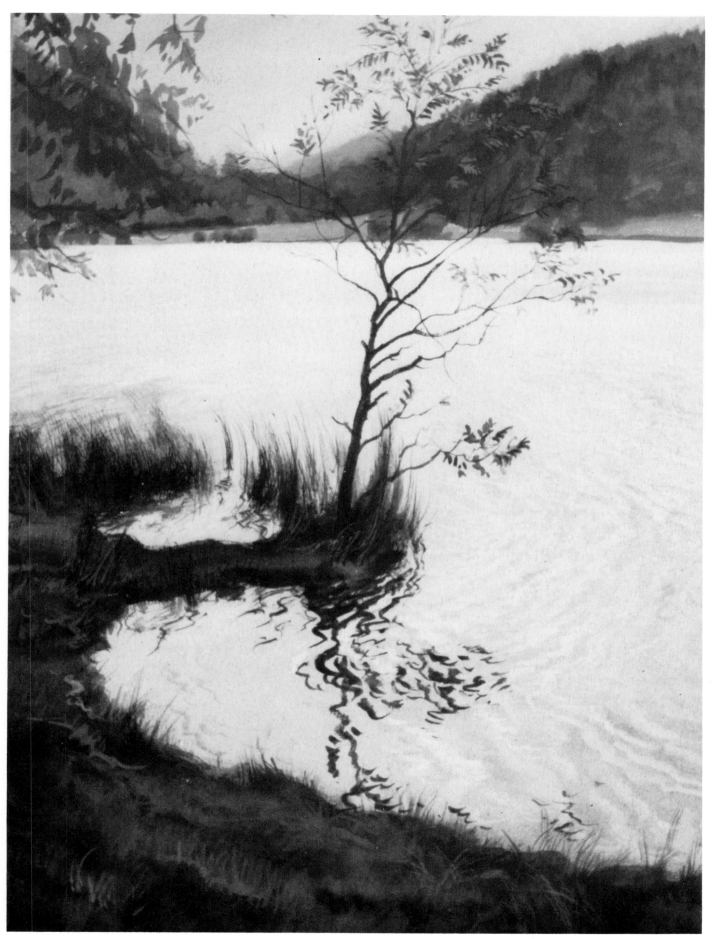

114 *Rowan and Tarn, Cumbria.* Gouache on grey paper. 16 × 11¼in

115 *Shingle Street, Suffolk*. Gouache on grey paper. 14 × 20in

Estuaries are a sort of halfway house between river and sea, and *Pin Mill* (another very popular spot with painters) shows the Orwell estuary at low tide (*Colour plate 21*), allowing use to be made of pools of water which reflect clouds and the dark shape of the boat. A grand sky echoes the shape of the foreground pool, and this movement is stabilized by the straight line of the distant river. The ropes give an interesting lead in to the boat, reflecting nicely as they rise up gracefully to the bow.

The Suffolk coastline is rich in subject matter for painters. Further north from the Orwell and its muddy estuary, it becomes a long sweep of sand and shingle backed by low sandstone cliffs. Beyond the mouth of the Deben (Constable country) is the well named *Shingle Street* (*Figure 115*). In this painting I reserved the light for foamy waves breaking on the shore, and muted the sky and beach tones to help this. A distant blue outline of higher land and a skyline of boats and huts relieve an otherwise austere landscape. The rather obvious brushmarks in the sky exaggerate the effect of a grey layer of cloud, but give it a spaciousness by arching over slightly. The beach curves upwards, and the two curves enclose and emphasize an almost level horizon. I also enjoyed painting the foam draining away down the shingle, meeting oncoming waves. A good landscape will conjure up sensations other than solely visual, and I like to think that one can hear the shingle rolling beneath the water, a soothing and distinctive sound as one walks along these beaches.

The warm waters of Greece make a delightful playground, and the bathers in Colour plate 22 are obviously enjoying themselves. The near figure is floating over the wave, with her feet higher than her shoulders. The part of the figure in the water is slightly distorted and a little darker than the head and shoulders, which catch the sunlight. Raw Sienna and Bengal Rose make a good flesh colour, with perhaps a little brown, especially against the greeny-blue of the sea. Brushmarks follow the wave's surface, changing in tone to show reflected light from the bathers and becoming white for the foam breaking on the crest. Although apparently random, these flecks of foam are carefully placed to give an aesthetically pleasing effect and to suggest movement and freedom.

116 *Afternoon, Andros, Greece.* Gouache and wax. 11¼ × 16in

117 *Morecambe Bay, Lancashire.* Gouache on grey paper. 14 × 20in

From a high viewpoint, a calm sea displays texture rather than individual details. In *Afternoon, Andros* (*Figure 116*) a high sun glints on the water, and I used a wax resist to obtain a sparkling effect of light. I drew horizontal lines of wax in a narrow strip down the centre of the sea, where the light had its greatest effect. Then I washed Bengal Rose and Raw Sienna over this and when dry, extended the wax over it in more defined lines. Indigo and a little of the red were continued over the sea area. To avoid the same texture in the sky, I damped the centre part and painted Indigo washes up to this, giving a smoother transition in the tonal change. I painted the land mass in much darker tones using Prussian Blue as well as other colours with a suggestion of Golden Yellow (I used this colour to give the land a different hue to the sunlit water). Finally brown and Indigo produced a dark foreground with a hard edge against the sea and a softer one further to the right.

Water does not have to occupy a large section of a painting to be important. In *Morecambe Bay* (*Figure 117*), seen from a distance of several miles, the sea is a minute strip, but an important recipient of light from a grandly spacious sky, filling a good three quaters of the picture. The light in the sky, using Raw Sienna, Golden Yellow and Bengal Rose, is just dark enough to show up the water, the rest being in very low tones.

So far we have examined water as found in large quantities, but additionally, dull surfaces are completely transformed by a thin, wet layer. Opposite my studio is a cottage with a small back yard; one day my neighbour was washing the yard down with a bucket of water. Both back and front doors were open and light streamed through, reflecting off the wet surface. *Washing the Yard* (*Colour plate 23*) is the resulting painting. The water spread in rings from where it struck the ground, similar to wavelets on a pond, but between them straight-edged reflections indicated the firm ground beneath. The walls reflected a more diffuse light, and bright sunlight caught grasses high on the left where a field ends at the wall top. Walls, window reflections and white frames were all toned down with Cobalt and Umber to give emphasis to the light from the doorway.

In *Road at Brackensgill* (*Figure 118*), a damp lane holds a puddle which extends off the lower edge of the composition. As the lane curves away, this curve is taken up by the top of a flattened pine tree and further beyond by lines on the hillside. A level valley floor and the trunk check this movement by pointing back down towards the far side of the lane. Although the lane and puddle are full of light, it is the snow-covered field which is brightest and detracts the eye from the very large area of lane surface. The encroaching puddle at bottom left prevents too obvious a line leading off the lower edge.

I hope the examples in this chapter show that wherever water is to be found, there are exciting opportunities for painting waterscapes. Whether you live in town or country, wet roofs, puddles or melting snow transfigure a scene which you may pass by daily without noticing. Include the effects of sunlight on murky canals or ditches and you can collect an endless variety of water subjects without tapping (excuse the pun) the more obvious beauties of streams, lakes and rivers. With sketchbook or camera in your pocket, and an ever enquiring eye, the most beautiful effects will unfold, sometimes most unexpectedly. With such tremendous variety abounding you should never have to say, 'I wonder what to paint?' Rather it should be, 'Which one of the many ideas I have shall I do next?'. I wish you happy hunting.

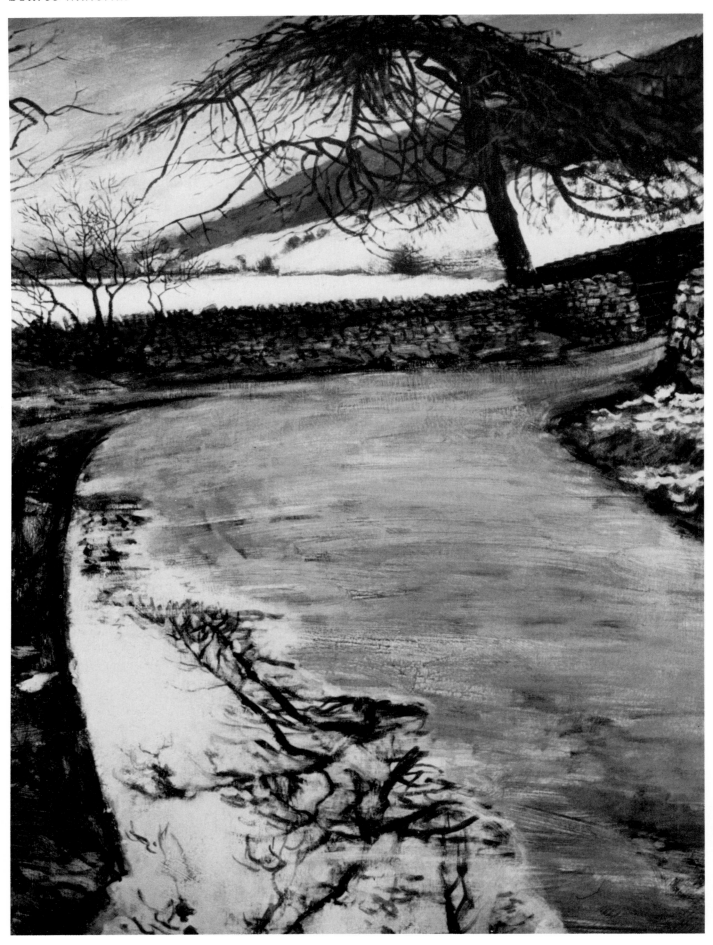

118 *Road at Brackensgill, Dentdale.* Acrylic on board. 30 × 24in

CHAPTER EIGHT
Collecting source material

There are many ways of translating the original experience which stimulates you to paint into the finished painting. The obvious one is to sit down in front of the subject with paints and easel and work directly from it. This is the most straightforward method and with controlled conditions (e.g. still life or model in the studio) cannot be bettered. In countries with a steady reliable climate the same applies, particularly if everything is static. Once we encounter variable weather, and continuously or swiftly moving objects, problems in observation arise. A good visual memory, well trained, is the only answer here to retain effects needed in the painting but which come and go while you work. Clouds with variable sunshine, figures passing by and moving water are a few examples.

Enough successful paintings have been done to justify this method, but there is a tendency to think it is the only correct way of working. However, enough successful paintings have been done by other methods to disprove this. Whistler could obviously not have painted his *Nocturnes* on the spot. He studied his subject, memorising all aspects of it which he wanted to include, and painted in the studio from his exceptional memory. Working like this, generalizations will occur which may actually help the painting, as one of the problems of painting on site is knowing what to leave out.

Often painters will partially complete work *in situ* and finish the job later in the studio. Various painterly aspects are helped by this, such as correcting drawing, altering tones to gain a better effect and organizing a colour

119 Sketch for *Flooding, Dent*. Pencil. 11¼ × 16in

120 *Flooding, Dent.* Gouache on white paper. $11\frac{1}{4} \times 16$in

scheme which may not totally reflect natural colour.

The time honoured method of collecting material is the sketch book. Used by probably all artists who also worked out of doors, perhaps to touch up a work in the studio, perhaps as a complete memory aid, the working sketch is very different from the on site drawing, however slight the latter may be. In its shorthand it may be barely recognizable by anyone but the artist. Figure 119 shows my pencil sketch for the painting in Figure 120. Covered with notes on colours and tones and decorated with arrows repositioning various features, it would be unintelligible scribble even to me unless I remembered the scene it describes. In the painting I tried to retain some of the spontaneity of the sketch while organizing the information to produce a coherent painting of flood water and lowering clouds.

Another pencil sketch done in wet weather (*Figure 121*) from inside a car is more recognizable, partly because there are no scribbled notes. This was transformed in the studio into the pen, wax and gouache painting in Figure 122. Again I attempted to retain the freedom of this original record, but it is a difficult thing to repeat. This was not, in fact, drawn with a pen, but with the filler tube in the bottle cap. It gives a variety of lines from very thick to a slight dry-brush look. Its unpredictability is an exciting challenge and certainly keeps you on your toes, ready to take advantage of any chance effect which might come along.

I started drawing in the top left-hand corner. Being right-handed, the paper beneath this hand remained clear of any blobs of ink which occurred. I used wax first of all in the sky, on the road and to give textures in the wall. Light washes of grey, green and brown added tone to the distant hill, foliage, roofs and walls and the road reflections. As I did this the wax drawing became visible and any further washes were also rejected. These first washes were allowed to dry and more wax used to draw in leaves, more wall textures and reflections. Darker washes then showed up the second wax application.

You can continue with this method for as long as you like, retaining successive colours to show through. In the dark foliage I used a little Indian ink to darken the washes, but it needs care as this covers wax resist.

121 Sketch for *Rainy Day, Kirkby Lonsdale*. Pencil. $11\frac{1}{4} \times 16$in

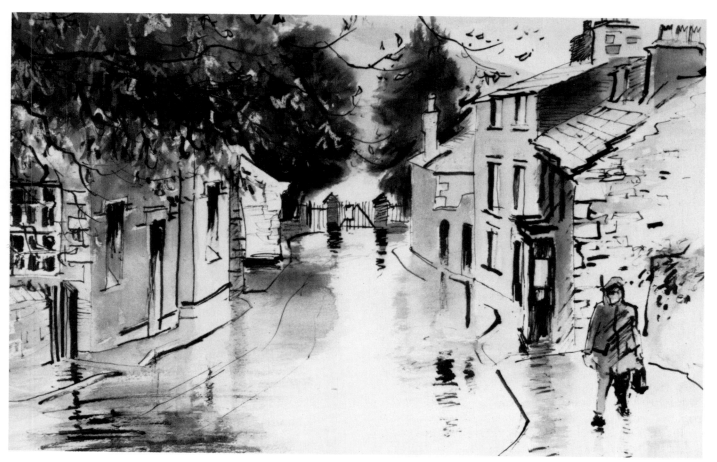

122 *Rainy Day, Kirkby Lonsdale, Cumbria*. Pen, gouache and wax. 14×20in

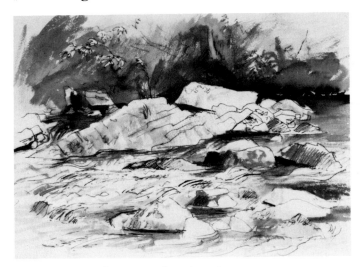

123 *Pen and Wash River Study.* 11¼ × 16in

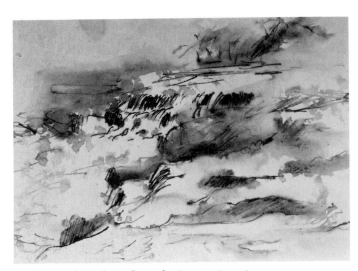

124 *Pen and Wash Study in the Rain.* 11¼ × 16in

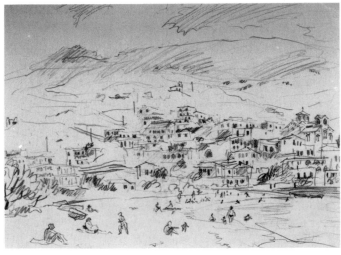

125

The pen and wash drawing (*Figure 123*) was completed in the studio by darkening some of the background tone to show up the rocks. I used pen lines to follow the water flow as it washes over and around the rocks. I also took care to leave areas of white paper, even though detail could be seen, to avoid darkening the tone of the water area too much. Another sketch (*Figure 124*) clearly illustrates one of the hazards of outdoor sketching with its rain spattered ink.

Sketching can be an enjoyable pastime in its own right and is a good discipline for sharpening up observation, especially with moving subjects such as figures. Three pages of a sketch book are shown here (*Figures 125–7*). I sat in the sunshine, leisurely watching the world disporting itself in and around the water, amusing myself and acquiring information which I could possibly use later.

126 Pages from a sketch book

127

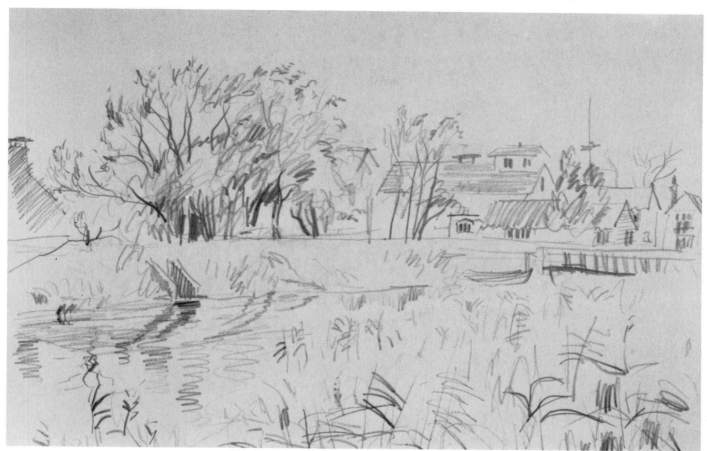

128 *Snape Maltings, Suffolk*. Pencil. $11\frac{1}{4} \times 16$in

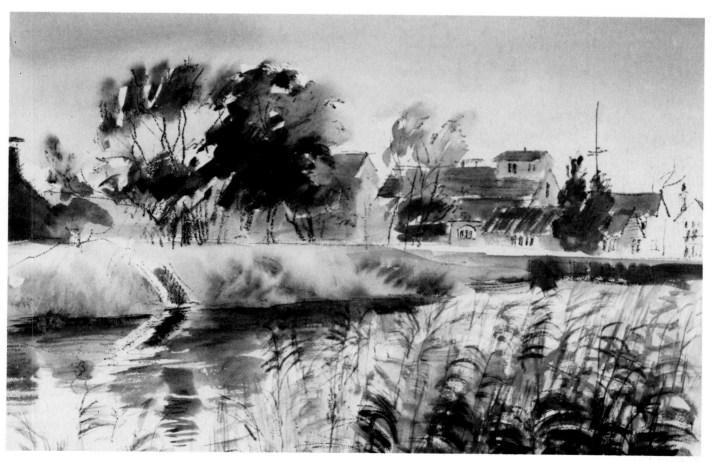

129 *Snape Maltings*. Colour washed photocopy. $11\frac{1}{4} \times 16$in

130 *River at Snape, Suffolk*. Pencil. 11¼ × 16in

For one drawing which I did at the Maltings near Snape (*Figure 128*) I only thought of colour washing later. The trouble was I was pleased with the drawing and did not want to risk spoiling it. After debating the point for a little while I decided to make a photocopy. I put the colour wash (*Figure 129*) on this and had both painting and drawing at my disposal.

That same afternoon at Snape was very pleasant and I wandered along the river bank, photographing and sketching. One little pencil sketch I did (*Figure 130*) shows how slight a drawing can be while still evoking the idea of place and time. This required very little drawing of the water itself, a few lines of reflection being enough to suggest water over a large part of the paper.

Figure 131 shows a watercolour – or rather a gouache used like watercolour – which I partially painted on site. When painting out of doors I use a small folding easel and stand to work rather than sit. This is a habit formed during student days. I paint from the shoulder at arms length, holding the brush near the end, allowing a freedom of movement which translates itself to the brush marks. I move around and step back to see the work from a better viewing distance, only occasionally moving in close and supporting the painting with my hand on the board for delicate passages. In the studio I sometimes pull up a high stool to rest my weary legs, but without realizing it, I find myself standing up, moving around again and pushing the stool away.

My outdoor painting equipment is basic. A satchel carries tubes of paint, a white plastic or china palette and a few brushes and plastic water bottle, with perhaps pencils, a 'dip in' pen and ink and a fountain pen. Choice of nibs is personal; I prefer a broadish nib which will give a fine line when used edge on. I tend to catch a fine nib on the paper in the excitement of drawing, either breaking it or splattering ink around.

On finishing the painting in Figure 131 after a couple of hours work, I returned home to find that its tonal range was insufficient. I darkened some areas, using the same colours, and painted some light in the water just under the trees and on the edge of stones, using the gouache as a body colour. I also scratched some light in, notably among the foliage of the nearest tree and in a little of the water. Prussian Blue, Indigo, Burnt Umber and Lemon Yellow were the only colours used.

I collect most of my material for painting with a camera. I use an Olympus OM–1, a basic manual camera with a good quality 50mm (standard) lens, and a Rollei 35 miniature camera. Standard means that the lens viewfinder gives an image the same size as seen naturally. Its limitation is the extent of the field it covers, particularly when viewing in confined spaces. The Rollei has a 40mm lens, a slightly wider angle than standard, reducing the image and so including more. This is my favourite as it will slip into a pocket and can be forgotten until a subject presents itself. It is very robust, having had rough treatment for over 12 years of its working life. Sadly, it is no longer on the market, but there are

131 *Sunnybank, Dentdale.* Gouache on white paper. 14 × 20in

numerous other makes with similar attributes. I used to prefer a black and white film which did not impose its own photographic colour on the painting, but found that colour processing could be much cheaper. Colour can help as a reminder of general hues and local colour (painted doors for instance), but I try to retain my own colour ideas from the original experience or build up colour schemes in the studio without being too influenced by the photograph. Occasionally a really good colour relation comes from the photograph itself, and I see no reason for not using this as a secondary source of inspiration. The few times I have used transparencies, I have found them very awkward to view while painting and I will not project onto the canvas and draw around the image. This prevents any individual distortions which give a painting its character.

I have painted on site literally thousands of times and know exactly what I want from the landscape. This means that any sort of memory aid, sketch or photograph, will serve to remind me of my original idea.

There is a strange stigma attached to the idea of 'copying' from photographs and there is no doubt that there are pitfalls to be avoided, but the camera has been used by artists since its invention. Great names like Delacroix, Courbet, Sickert and many more to the present day all painted from photographs at times. Some were photographers and some used photographs taken by others. The subject is a fascinating one and if you wish to explore it further I can recommend *The Artist as*

Photographer by Marina Vaizey. Suffice it to say here that the photograph as a working sketch is a perfectly legitimate way of collecting material. In some ways it is more difficult than painting or sketching from life, and you need to have a strong idea of the finished work to avoid a second rate imitation.

I have several reasons for using a camera. I prefer working in the studio where I can concentrate on the painting itself without being sidetracked either by external influences or by the landscape, which I am not wholly trying to imitate. Also, I need to be in my studio to meet and talk to visitors. Secondly I started by using sketches, but found that often a spontaneity achieved in this way was difficult to repeat a second time. This is noticeable between Constable's oil sketches and his finished works. When I turned to photography I found that transient effects of light or movement of water could usefully be captured in detail, thus avoiding the need to memorize all the changing elements. Thirdly, I dislike sitting still when out of doors; I prefer to walk through the landscape absorbing its sounds, smells and general atmosphere and in a walk can collect a dozen or more ideas for future paintings rather than a few sketches or one finished work.

Having said this, I think it is important to maintain direct observation and drawing and I will occasionally sketch or paint on the spot for this reason. I paint and draw from the model and do a few portraits and still lifes also. This is my own personal way of working which I

132 Photographic memory aid for *Epping Forest*. London Transport Poster 33 × 25in

133 Four mounted photographs. Memory aid for *Flintergill*.

have established after years of experimentation. Others may find it quite unsuitable and if painting *en plein air* is what you want, I should be the first to encourage you. The methods of working described in this book will apply to painting indoors or outdoors equally well.

For a painting of mine used as a London Transport poster, *Epping Forest (Colour plate 24)*, I used a black and white photograph as a memory aid *(Figure 132)*. I spent a day wandering around the forest, photographing and sketching and generally absorbing the atmosphere of the place. Back at home, all these records were studied together before settling on this one. A certain amount of what Marina Vaizey calls 'editing' is evident, both in the simplification of foliage and the re-arranging of features into a more coherent composition. I made much more of the background figures than in the photograph. I had no colour notes, and built up the colour scheme in the studio, partly from memory and partly as the painting developed before me.

Mention has been made of lens angles. I do not carry an array of lenses around with me and will cover a scene by taking several shots if it extends beyond the viewing area. This usually happens in a confined space when it is impossible to step back in order to get more on the film.

In any case, stepping back will alter the relative sizes of things and result in a quite different picture. Figure 133 shows four photographs mounted together, giving the information used in *Flintergill (Figure 78, Chapter 5)*. Perspectives will alter as the camera is moved from shot to shot, and this must be corrected in the painting, unless it is seen as a desirable feature to enhance a sense of space through exaggeration.

Whichever method you choose to collect source material for your waterscapes, two constants remain: a genuine love and fascination for the subject and a driving compulsion to express it in terms of paint. Without the former one would quickly tire of struggling with the complex problems of water in its various states and the latter is the force which makes all artists different from the person who can accept and enjoy an experience in a passive manner, without being driven by an urge to create some personal statement about it.

I hope my emphasis on studio painting has not deterred those of you who love to work outside. I also hope that it has encouraged those who experience difficulty in working exposed to the elements with a moving, complex subject before them.

CHAPTER NINE
Summary

Water is beautifully and complexly fascinating. Although I hope these chapters have covered most aspects of its changeability, I know I have missed things out, either for want of space or because I have not personally experienced and painted them. I have never seen the Arctic or Antarctic Seas or watched flash floods transform a desert landscape. One's experience is limited by requirements other than simple desires, but I do hope that I have shown the potential for providing subject matter within the confines of a small part of the Earth's surface.

The important thing for me is that I am never short of ideas for painting and even if I were to restrict myself to waterscapes I should always have several paintings in mind waiting to be done. Always look through the eyes of a painter and subjects will continually present themselves to you. This can happen at inconvenient moments. Some of my best ideas were seen disappearing in the car mirror when stopping was out of the question! I nearly always carry a miniature camera in my pocket when I go for walks or cycling or when visiting new places. Failing this I have sketched on the backs of envelopes or even memorized something and then made a note as soon as possible afterwards. I find that setting out to look for a picture is sometimes disappointing, and, conversely, the most exciting ones are stumbled upon, taking you by surprise. Lighting is also an important factor and this is rarely dependable. You arrive at a preselected spot to find a quite uninspiring view, which the other day stirred the imagination. So, if I have one maxim for collecting subjects it is to be prepared.

In addition, never be afraid to experiment, either with viewpoints to achieve more stimulating compositions or with various media to discover new ways of expressing water. Vary your palette so that you experience different colour mixes and combinations. Painting is not just copying, and the colour *effect* of a natural landscape may be arrived at without slavishly imitating the colour as seen. Do not be inhibited by too many 'do's' and 'don'ts' – painting is an adventure and each picture a voyage of discovery.

Of course, I do not always live up to these words. As a professional artist I must rely on tried and tested methods which I have been taught, or have discovered myself, but I do look forward at the start of each painting to the possibility of something new and exciting happening. It is this which makes the *creative* artist.

Much can be done to understand water without actually painting it. The way it moves around obstructions and folds and breaks with wind and current can be studied while walking or sitting by it, perhaps making a brief pencil note to help remind you later. If you are an outdoor painter, use a photograph to study in detail later, at your leisure, as Dégas photographed his ballet dancers, frozen in movement.

Make a point of revisiting places you have painted in order to see them under different conditions and to try out new ideas on the same subjects, thus giving a chance for comparison. Even under the same conditions a variation in technique or medium will provide a different painting.

Try to see alternative compositions in the same subject before settling for a particular one and use upright and horizontal formats of varying proportions. These can have a big influence on the mood of the picture. If you seek out different kinds of water you will be surprised how often the shape of the picture is decided for you. If you look for waterscapes in urban and rural surroundings, in fair weather and foul, there is no limit to the potential subject matter you will find. And do try sketching and photographing as well as painting on the spot – it will broaden your understanding of the subject at the very least.

Enjoy your waterscapes, both for themselves and the painting of them.